CONTEMPORARY RUSSIAN ART

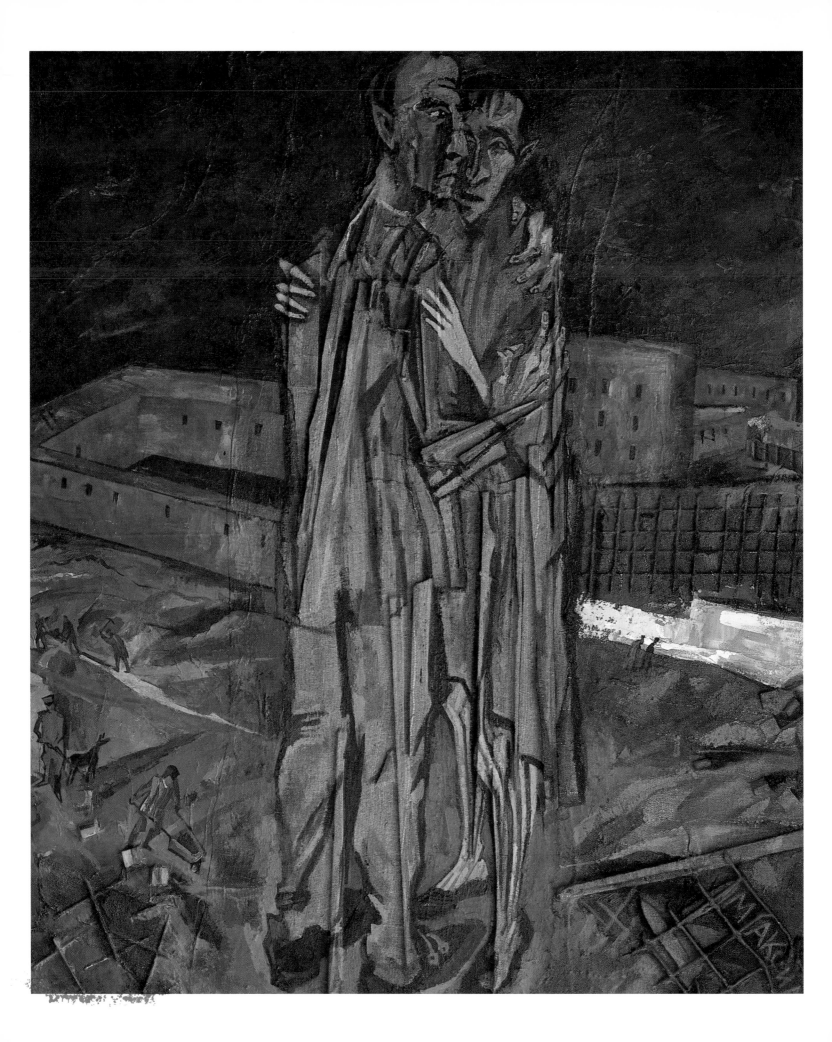

contemporary

RUSSIAN ART

MATTHEW CULLERNE BOWN

PHAIDON | OXFORD

Посвящается Натусеньке

Phaidon Press Limited, Musterlin House,
Jordan Hill Road, Oxford OX2 8DP

First published 1989
© Phaidon Press Limited 1989

A CIP catalogue record for this book is available
from the British Library

ISBN 0 7148 2555 7

Design by James Campus

Typeset in Frome by Tradespools Limited
in Bodoni Book
Printed and bound in Great Britain by
Butler & Tanner Limited, Frome, Somerset

Frontispiece.
MAKSIM KANTOR. *People in Desolation.* 1987.
Mixed media, 240 × 200 cm (94½ × 78¾ in).
Galerie Nannen, Emden, West Germany

CONTENTS

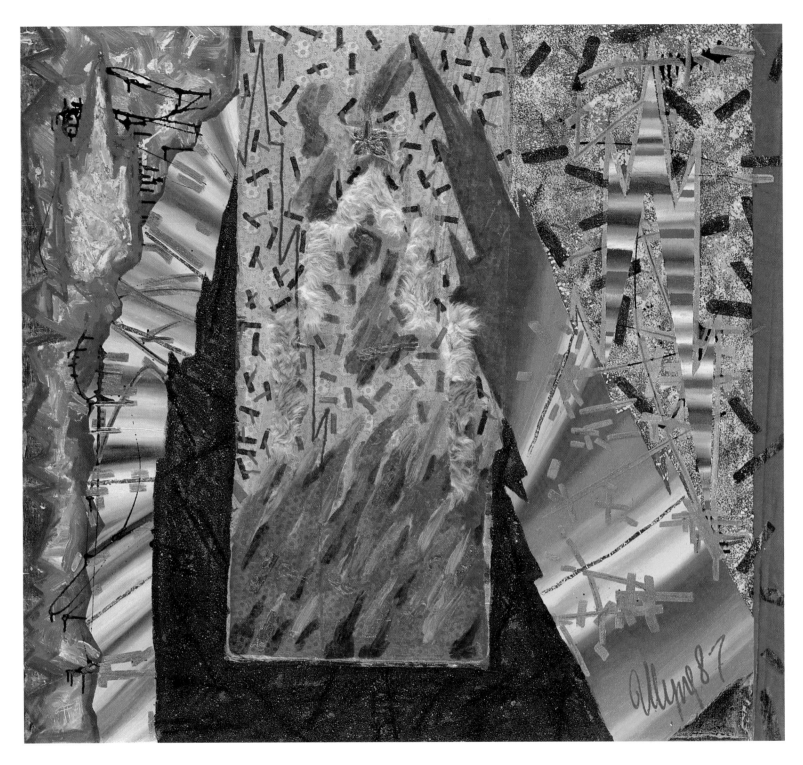

1. **SERGEI SHUTOV**. *Fire in Moscow University*. 1987.
Mixed media, 130 × 150 cm (51⅛ × 59 in). The artist

PREFACE

Russia itself is sufficiently vast, but it is today just one member-republic of the Soviet Union. How does one begin to conceive of the Soviet Union, its myriad nationalities and cultures? I am not qualified to make the attempt; rather, I have concentrated in this book on artists who work, or who frequently exhibit, in Russia itself, and in Moscow in particular. All the same, there is inevitably an area of overlap between the concepts 'Russian' and 'Soviet': I have tried not to use them indiscriminately. I have also attended most to those artists whose work manifests what I perceive to be peculiarly Russian ideas about art. This has meant the exclusion of some excellent artists who seem to owe most to the indigenous traditions of Soviet republics other than Russia. Nevertheless, for all my efforts to narrow the focus of the book, it could never claim to be more than a whistle-stop tour.

Many people have contributed to this book, in innumerable ways. There are too many to mention them all by name. I would like to thank in particular Natasha; Lev Melikhov, my photographer; Julia, who first introduced me to some of my favourite painters; Mr Zimenko, of the journal *Iskusstvo*, and Messrs Rozhin and Polityko, of the journal *Tvorchestvo*, all of whom generously supplied illustrations; the Stroganov Art School, Moscow, which looked after me in the academic year 1986–7; the British Council; Kathleen Mullaniff; Tess Jaray; Noel Forster; Daisy Goodwin; Brian Stafford; Peter Townsend; William; and Clive and Flora.

I also extend my gratitude to everyone else who has been involved, and in particular to the artists who gave unstintingly of their co-operation, some of whom, for reasons of space, I regret to have been unable to include in the book itself.

Matthew Cullerne Bown
London, August 1988

THE RUSSIAN ARTISTIC HERITAGE

'Nothing that you hear about us in England is true,'
was the Princess's hopeful beginning.

FROM *REGINALD IN RUSSIA* BY SAKI, LONDON, 1910

Russia has never been able to decide to what extent it should consider itself part of Europe and to what extent it should hold aloof. This indecision is reflected in the relationship of Russian art to the mainstream of Western culture, in which it paddles at irregular intervals. It is questionable how far Russian self-containment has been imposed by the State, and how far it represents a popular attitude. During the early years of the twentieth century, when Russian artists for the first and only time in their long history were participating fully in the artistic life of Europe, the avant-gardist Nataliya Goncharova liked to assert, with disarming chauvinism, that all art was dead or decadent except in Russia. The tangential relationship of Russian to Western culture can be painful for Russians; many of the intelligentsia cherish the hope of closer ties with the West, despite the qualms and shrinking of the nation as a whole.

Very few cultures develop in complete isolation. Russian art has made repeated borrowings in the course of its history, but imported styles, rooted in Russian soil, tend to grow in an independent way. The concept of perpetual stylistic evolution, so central to Western thinking about art, does not have the same importance in Russia. Icon painting still held sway while the Renaissance was sweeping Europe. In the twentieth century, academic techniques, relegated in Europe, were revived in Russia to provide a sure foundation for socialist realism.

While Russian art acknowledges above all the influence of European artistic language, its forms, once transplanted, often become the vehicle for a mysticism which is rarely found in the West. Russian art often transcends the intellect and plays down the sensual appeal of painting in favour of a supreme idea. Some people, pointing out that Russia encompasses a vast expanse of

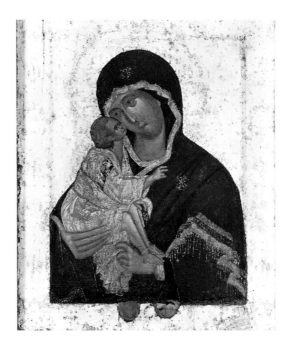

2. THEOPHANES THE GREEK.
Our Lady of the Don.
Late 14th century. Icon, tempera on panel,
86 × 68 cm
(33¾ × 26¾ in).
State Tretyakov Gallery, Moscow

land, athwart Europe and Asia, ascribe this tendency to the influence of Eastern thought. It is probably more legitimate to trace it back to Russia's first association with Byzantine culture and the founding of the Orthodox Church in Kiev, in the Ukraine, in 988. The characteristic modes of expression of Byzantine art – icon painting and monumental religious wall-paintings and mosaics – which were adopted by the Russians, display precisely this tendency towards mysticism and preoccupation with a supreme idea [Pls. 2, 3].

In Byzantium, *eikon* meant simply 'image', one which might as well represent a courtesan as a saint; in Russia, however, icons acquired a predominantly religious role. The asceticism of Byzantine style was considered indispensable and over-realistic images were regarded as 'temptations of the devil'. They were not intended as

accurate descriptions of any kind of reality, even a heavenly one, but rather as surrogates which provided a means of communion with God. An icon which failed to perform satisfactorily could, like a recalcitrant child, be made to face the wall and even be beaten.

Icon painters used a strictly limited range of facial expressions, poses and compositions. Today, inside and outside the area of high art, painted, graphic, photographic and sculptural images of Lenin abound in the USSR. All of them are based on an established range of visual stereotypes. That Lenin's eyes become progressively more slanted as you travel eastwards

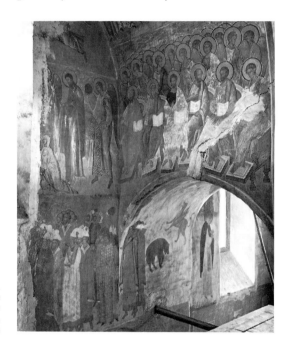

3. Frescoes. 1500–2. Church of the Birth of the Virgin in Ferapont Monastery, Vologda

through the Soviet Union is the only noticeable deviation from orthodoxy. Shops continue to sell folders with retouched photographs of the entire Politburo, suggesting an assembly of saints or angels, presided over by a General Secretary whose distinctive birthmark has miraculously disppeared. The aim of such an image is identical with the icon: it is transcendental; it encourages the Soviet citizen to commune with the highest ideals of Communism.

Traditionally the church murals and the device of the iconostasis, or screen of icons, had an evangelical function, which the Communist State found congenial. But traditional images were not just emblems of the religious Establishment. The gorgeous icons produced in the Tsars' workshops and now given pride of place in Soviet museums are only half the story. Even the most rudimentary sketch of a holy image on a scrap of

paper could function as an icon, and the production of icons of a humble kind took place outside the patronage of the State. Such icon painting entered the realm of folk or peasant art, a genre which Russian artists of all persuasions still hold to be a touchstone of integrity and genuine sentiment. Icons are still produced, and the authorities recognize their importance by refusing to allow them to be exported. The icon represents a rich stratum of popular belief, a religious sentiment which remains contemporary despite the attempts of the Communist State to extinguish it. A profound mysticism and the icon painting tradition itself are very influential in present-day Russian art. A notable exponent of this tradition is Mikhail Shvartsman (born 1926) [Pl. 4].

It was not until the eighteenth century that the Western tradition really began to permeate Russian art. In previous centuries the Russian Church and State had fostered an intellectual and cultural isolation, which the Renaissance had not penetrated to any marked degree. European influence only began to make its mark in 1703 when Peter the Great founded the new Western-style city of St Petersburg (renamed Petrograd in 1914 and Leningrad after the Revolution). In 1757 the Empress Elizabeth established the Academy of Arts (now the Repin Institute) on the lines of the French Academy, and by the end of the century Catherine the Great had amassed in the Hermitage an unparalleled collection of Western European art.

The assimilation of Western art went hand-in-hand with the assimilation of European culture in a wider sense. Peter the Great remodelled Russian society along lines suggested by his European experience. Under Catherine the Great (a Prussian princess), French and German writers and philosophers were welcomed to stimulate an enlightened despotism. Similar links between cultural innovation and social and political change are apparent in our own century, with Lenin during the Russian Revolution and with Gorbachev and *perestroika*.

Eighteenth-century Russian art is notable above all for its portraits. Academism was grafted on to the seventeenth-century tradition of *parsuny*, portraits of the living painted in the style of icons, which had first been sanctioned by the Church in the 1550s. A strong tradition of portraiture persists to this day in Russia: painting the right pictures of the right people is a well-worn route to success in the official art world. More generally, in the eighteenth century a

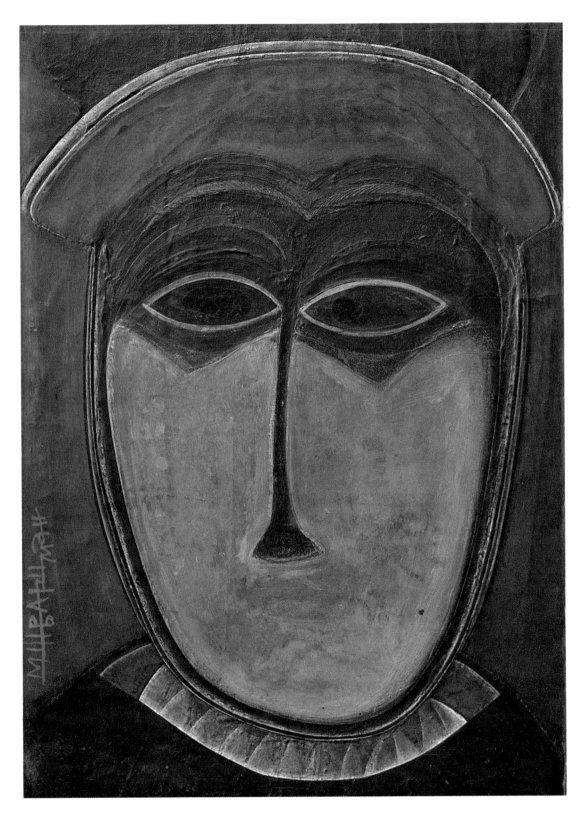

4. MIKHAIL SHVARTSMAN. *Cosmic Herald.* 1960.
Oil on panel, 50 × 40 cm (19⅝ × 15¾ in). The artist

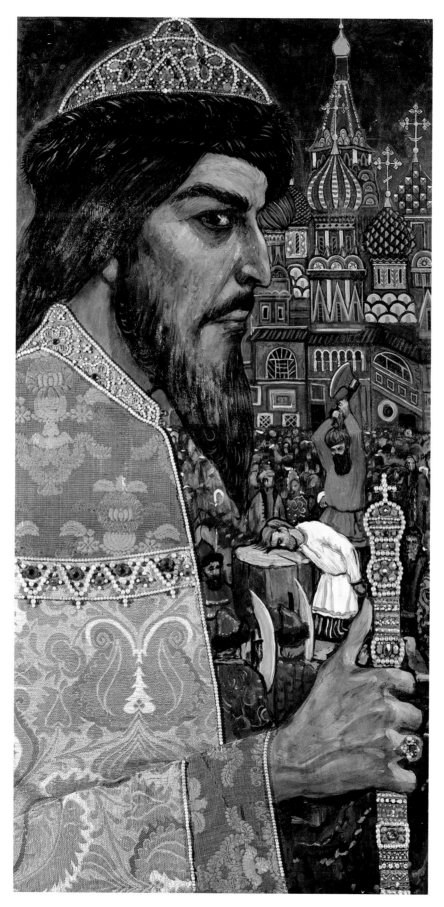

5. ILYA GLAZUNOV.
Ivan the Terrible.
1974. Oil and collage on
canvas, 152 × 78 cm
(59⅞ × 30¾ in).
The artist

sentimental link was established between the classical tradition in art and Russia's growing stature as an imperial power. This imperial metaphor was appreciated by Stalin, who revived academism in art and neo-classicism in architecture in order to realize his grandiose conception of the new Communist State. Nowadays this attitude is the object of satire by some artists who mock Moscow's former pretension to be *Trety Rim*, the Third Rome, after Byzantium and Rome itself.

The high-point of Russian academic painting

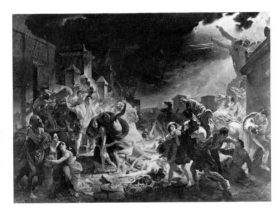

6. KARL BRYULLOV.
The Last Day of Pompeii.
1833. Oil on canvas,
456.5 × 651 cm
(179¾ × 256¼ in).
State Russian Museum,
Leningrad

came in the early nineteenth century, when relays of students were despatched to Rome to study, and duly returned with a number of huge, brilliant canvases, the best of which now hang in the Russian Museum, Leningrad. One such is by Karl Bryullov (1799–1852), *The Last Day of Pompeii* [Pl. 6], a painting which travelled Europe and inspired Bulwer-Lytton to write his novel of like name.

The sheer technical ambition revealed in the work of artists such as Bryullov still motivates some artists today. The Soviet art education system continues to train people, in theory, to a comparable level of academic proficiency, using methods of teaching which may have changed little in more than 200 years. After leaving school at about seventeen years of age, an aspiring artist may spend up to four years at an intermediate art school and another five or six years at a higher art institute. Entrance to a higher institute is by an exhaustive month-long process of practical and theoretical examinations. The teaching of all disciplines revolves around a nuclear course of painting, drawing and sculpting from life, of an emphatically academic nature. This basic training provides the *gramotnost*, the skills or 'grammar', required for the production of socialist realist art. It is apparent, however, that although Soviet art still produces its fair share of enormous figure

compositions, none of them displays anything like the panache of Bryullov and his contemporaries 150 years ago.

As the nineteenth century progressed, under the influence of philosophical debates arising in Russia itself, this relatively new breed of academically trained artists began to eschew classical subjects in favour of religious, social and genre themes with a contemporary relevance. Many of the artists espoused a proselytizing realism which echoed the evangelism of old Russian religious painting. Outstanding were the Wanderers, a group of realist painters who took exhibitions of their socially concerned pictures from town to town. In a way which finds many parallels in Russian literature, they used art to say things which political censorship would not allow to be uttered directly. Their work, promulgated by revolutionary critics such as Chernyshevski, formed the young Lenin's taste and encouraged in his mind the concept of a politically aligned art.

Pictorial devices favoured by the Wanderers employ metaphors which have appealed to generations of realist painters since. In *Barge-haulers on the Volga* [Pl. 7] by Ilya Repin (1844–1930), the

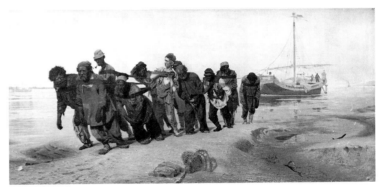

gaze which the young man lifts from his drudgery calls to mind the vast expanses of the Motherland and expresses an optimistic belief in the future of Russia. It is a motif which has been widely adopted by socialist realist artists. The composition in Repin's painting, based on a diagonal movement through space, also refers by this dynamic to the Russia outside the painting, its past and its future. It is a device used by Aleksei Sundukov (born 1952) in *The Queue* [Pl. 8] which, when first exhibited in 1986, ushered in a new period of social comment in Russian painting characteristic of the Wanderers themselves.

The latter part of the nineteenth century witnessed a growing national consciousness among Russian artists, of which the socially tendentious art of the Wanderers was only one

7. ILYA REPIN.
Barge-haulers on the Volga.
1870–3. Oil on canvas,
131 × 281 cm
(51½ × 110⅝ in).
State Russian Museum,
Leningrad

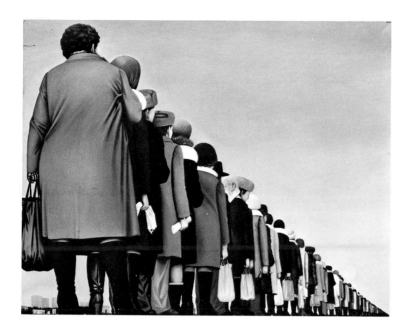

8. ALEKSEI SUNDUKOV.
The Queue.
1986. Oil on canvas,
200 × 230 cm
(78¾ × 90½ in).
Ministry of Culture,
RSFSR

ary artist, Ilya Glazunov (born 1930). His work demonstrates a deliberate Russianism, which perhaps explains its popularity with a fiercely nationalistic people. This is sometimes combined with a militant avowal of religious belief. He pays stylistic homage to the *fin de siècle* movement of which Vrubel was a part, but the chilling nature of Glazunov's world view far outdoes Vrubel's melancholy. The figures in Glazunov's paintings wear mask-like expressions, suggesting rigor mortis. His repeated portrayal of violent death suggests a positive fascination. An example of this is his painting of Ivan the Terrible [Pl. 5] – a man whom, thanks to Eisenstein, Russians instinctively associate with Josef Stalin.

The Russian and Slavic revival culminated in the formation of the World of Art group in the

manifestation. Artists and critics began to excavate neglected aspects of their heritage, such as folk-art and religious painting, and to illustrate Russian and Slavic themes. Great emphasis was laid by many artists on fantasy and decoration in a reaction against the sombre canvases of the

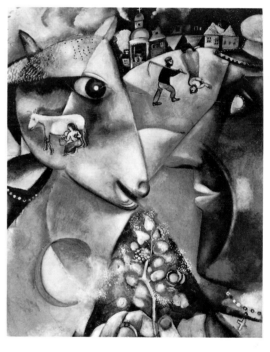

10. MARC CHAGALL.
I and the Village.
1911. Oil on canvas,
191.5 × 151.5 cm
(75⅝ × 59⅝ in).
The Museum of Modern
Art, New York

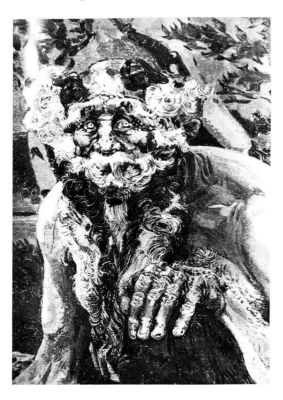

9. MIKHAIL VRUBEL.
Pan.
1899. Oil on canvas,
124 × 106.3 cm
(48¾ × 41¾ in).
State Tretyakov Gallery,
Moscow

Wanderers. The leading exponent of this Russian revival was Mikhail Vrubel (1856–1910), whose work is suffused with a mysticism focused not on redemption but on diabolic power [Pl. 9]. A similar acknowledgement, even glorification, of dark forces is present in the work of a contempor-

1890s. This was an association of artists, designers and writers who published a journal (called *World of Art*) and organized exhibitions. A prime mover of this group was Sergei Diaghilev, the impresario who brought the work of contemporary foreign artists into Russia and in 1906 organized the first major exhibition of Russian art abroad, at the Salon d'Automne in Paris. The éclat of this exhibition marks the beginning of the short period when Russian artists at last began to participate fully in the cultural life of Europe as a whole. Inspired by the increased intercourse with major European cities, in particular Berlin, Munich, Vienna and Paris, a multitude of artistic groups sprang up in Moscow and St Petersburg in

the years before the Russian Revolution of 1917. A detailed chronology of this complex period is outside the scope of this book, but a bewildering variety of movements emerged. At first these displayed the continuing influence on contemporary painters of folk-art traditions: the Russian on Larionov (1881–1964), for example, and the Jewish on Chagall (born 1889) [Pl. 10]. Soon, however, they began to ally themselves with the mainstream of European formal innovation by the elaboration of rayonnism, cubo-futurism, suprematism and constructivism.

Suprematism and constructivism, of all the manifestations of Russian art, continue to receive the most attention abroad. This is understandable in view of the influence which they exerted on the development of Western art. However, the detailed exegesis to which these movements have been subjected in the West tends to obscure the Russians' own perception of them, which is some-

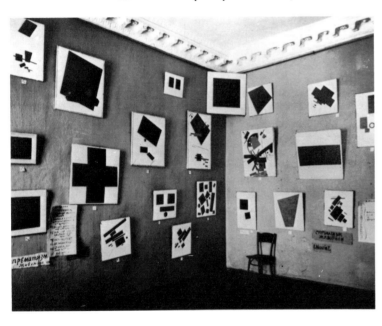

times at variance with our emphasis on their formal innovativeness. If we consider two key figures of this period, Kazimir Malevich (1878–1935) and Vladimir Tatlin (1885–1953), we can see that in one sense, both Malevich's suprematism and Tatlin's constructivism derive from the familiar nexus of Russian beliefs about art; in particular, from the belief in its duty to unite the viewer with a supreme idea which exists outside the work itself. For example, when Malevich first showed his *Black Square* he hung it high up in the corner of the room, the very place where icons are traditionally hung [Pl. 11]. He described the square, in terms suggesting a new-born Christ, as a 'living, regal infant'. It

was, to all intents and purposes, an icon for the new age which Malevich already felt to be imminent in 1915. As far as constructivism is concerned, this was essentially a spiritual pursuit, even though it often aspired to a practical role. Malevich himself pointed out that Tatlin's projected *Monument to the Third International* [Pl. 12] was, like nearly all Tatlin's ideas, entirely impracticable – if it had been built, it would have collapsed. Its significance is as a grand gesture, a statement of faith in a certain, perhaps betrayed, perhaps equally impracticable, vision of the Revolution.

The virtual extinction of avant-gardism under Stalin is properly blamed on the repressive policies

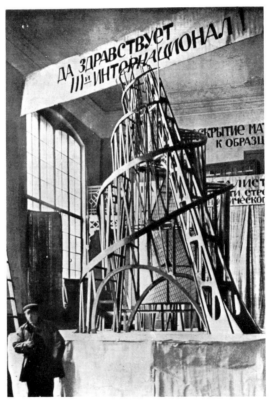

12. VLADIMIR TATLIN. Model of the *Monument to the Third International*. 1919

which he implemented in the 1930s. However, long before that many artists began of their own accord to draw back from the avant-garde frontiers in painting and sculpture. By the early 1920s many of the avant-gardists who did not quit Russia after the Revolution had begun to concentrate on design and architecture in order to give their work a greater degree of social relevance. Malevich spoke of the painter as 'a prejudice of the past', and even though later on he returned to painting, he rejected abstraction. More importantly, the cultural conservatism of the Soviet leadership was exploited by realist artists, who used political weapons in an internecine struggle against avant-gardists. Ever

11. Kazimir Malevich's room at the *0.10* Exhibition, Moscow, 1915

13. **FRANCISCO INFANTE.** From the series *Structures*. 1987.
Snow, wood, paint, mirror and sunlight, 150 × 2 × 2 cm
(59 × ¾ × ¾ in). Countryside near Moscow

since then, progressive artists in the USSR have had to combat the readiness of their conservative counterparts to mobilize political opposition, thus creating an art world ridden with acrimony.

Although it is impossible to judge how avant-

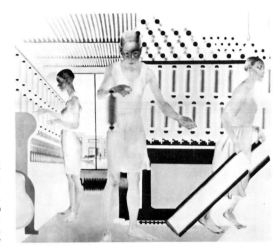

14. ALEKSANDR DEINEKA.
Textile Workers.
1927. Oil on canvas,
171 × 195 cm
(67¼ × 76½ in).
State Russian Museum,
Moscow

gardism would have evolved in Russia had it been allowed to do so unhampered, the evidence of the 1920s indicates that it might not have loomed so large in Russian art as Western prejudice sometimes suggests. Even the non-conformist artists who emerged from the wainscot after Stalin died were initially more inclined to surrealism than to abstraction: a response to the nightmarish quality of the times through which they had lived. However, none of this should diminish the achievement of a handful of courageous artists and private collectors, who managed to keep this part of Russia's artistic heritage alive, often in the face of considerable harassment and persecution. These are the people who are largely responsible for the rehabilitation of the avant-garde by the authorities in recent years. They are too numerous to list here, but among them is Francisco Infante (born 1943), a pioneering kinetic artist in the 1960s, whose severe, poetic installations in the Russian countryside draw on Malevich and constructivism [Pl. 13].

Artists such as Malevich also devoted much of their time in the 1920s to teaching in the post-Revolutionary art schools, where, for a brief period until 1930, academic training was replaced by an innovative multidisciplinary approach having something in common with the Bauhaus. Some of the first graduates of these schools, in particular those who later formed *OSt*, the Society of Easel Painters, developed a synthetic language which acknowledged the formal discoveries of the modern movement and combined

them with an attempt to illustrate positive aspects of life in the Communist State. Aleksandr Deineka (1899–1969) graduated from Moscow *VKhuTeMas* (Higher Artistic and Technical Studio) in 1925. His graphic dexterity, lightness of touch and appropriation of a variety of stylistic influences, are an inspiration today for artists on the so-called left, or progressive wing of the official art establishment [Pl. 14]. A colleague of Deineka's in *OSt* was Aleksandr Tyshler (1898–1980), a stage-designer and former pupil of Ekster in Kiev, who created a dreamlike world which conveys an overwhelming sense of human frailty and isolation [Pl. 15]. Tyshler's work, almost unknown in the West, finds an emotional echo today in the paintings of Nataliya Nesterova (born 1944), whose deliberate withdrawal from the conventional heroic themes of Soviet art and reaffirmation of values on a human scale dominated much critical discussion in the official art world during the 1970s [Pl. 16].

15. ALEKSANDR TYSHLER.
*Lyric Cycle,
Composition no. 3.*
1928. Oil on canvas,
70 × 60 cm
(27½ × 24 in).
State Tretyakov Gallery,
Moscow

But the most striking form of visual communication thrown up by the Revolution was that of poster design, which used dramatic combinations of image and text that now seem inseparable from the concept of Russian Communism itself [Pl. 17]. Echoing the continual proliferation of posters around the Soviet Union are the vast, gnomic slogans, *losungi*, which catechize the population

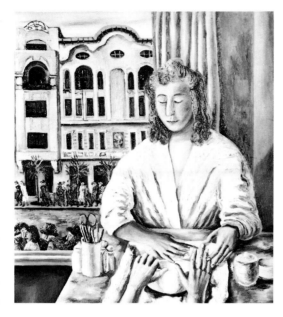

16. NATALIYA
NESTEROVA.
Window.
1986. Oil on canvas,
97 × 87 cm
(38¼ × 34¼ in).
Private collection, France

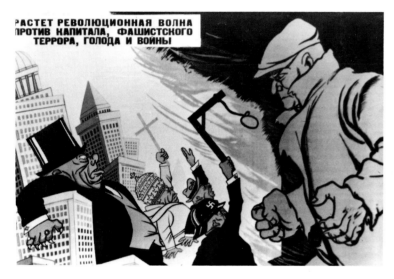

17. V. DENI.
*A revolutionary wave is
growing against Capital,
Fascist terror, hunger and
war.* 1931. Poster

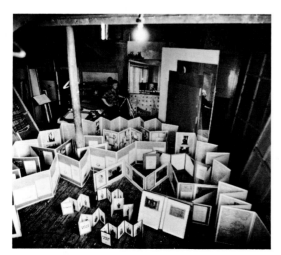

18. Photograph of Ilya
Kabakov in his studio,
surrounded by his albums

from the façades of buildings. These are essentially icons, in that a supreme idea is expressed in forms which are apprehended as a whole, as purely visual images. They repeat some article of faith, like 'Glory to the Communist Party of the Soviet Union', which has existence only in its iconic manifestation: without the *losungi* there might be no concept! In the reflected glare of these word-icons, contemporary artists such as Ilya Kabakov and Erik Bulatov (both born 1933) have utilized image-text combinations of their own in an attempt to analyse, neutralize or provide an astringent alternative to cloying Communist ideology [Pls. 18, 19].

Posters are clearly the proselytizing art form *par excellence* – after all, even people who detest Communism love its posters. Until Lenin's death in 1924 posters sufficed as a vehicle for visual propaganda, and a variety of art forms, including avant-gardism, were allowed to flourish at the same time. Although cultural figures were even

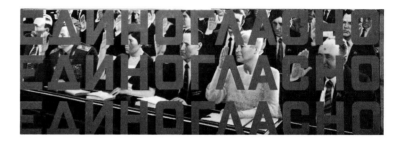

then being forced to bow to political pressure, many artists today extol this brief period of cultural pluralism as the Golden Age of Soviet art. But it was not to last: as Stalin consolidated his hold on political power, the curtain descended on the vital, idealistic art of the 1910s and 1920s. By way of a finale, Vladimir Mayakovski (1893–1930), the poet, playwright and graphic artist, who as much as anyone embodied the bold spirit of the times, shot himself in 1930.

In 1932 all independent artistic groups were forcibly disbanded, and official organizations such as the Moscow Artists' Union began to be formed. In 1934, at the first conference of the Union of Writers, socialist realism was officially defined as the sole permissible artistic method. It was called a 'true and historically concrete depiction of reality in its revolutionary development ...combined with the task of educating the workers in the spirit of Communism'. In other words the prosaic realism and socio-political content of the Wanderers was to coalesce with the striving towards a supreme ideal inherent in

19. ERIK BULATOV.
Unanimously.
1987. Oil on canvas,
80 × 240 cm
(31½ × 94½ in).
Kunstmuseum, Basel

icon painting. It was a unique kind of artistic dialectic, and the contradictory requirement to paint pictures which were simultaneously realistic and grounded in fact on the one hand, and fully expressive of an ideal state of affairs on the other, resulted in paintings in which even the most commonplace scene often acquired an air of unreality. At times, in the work of Arkadi Plastov (1893–1972) for instance, this unreal air approached a genuine mythic quality [Pl. 20], but as often as not it was plainly ludicrous.

However clear this judgement may be today, socialist realism during the time of its Stalinist flowering was officially proclaimed as an art to rival the great achievements of past European culture. Art journals of the 1930s and 1940s are full of reference to it as an art of 'world-historical significance' and similar epithets. Thus the preference given to academic language was not just a

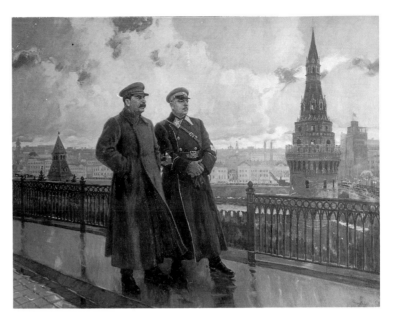

result of innate conservatism among cultural policy-makers, or of the need for an accessible, didactic, narrative art, but also a mark of Stalin's overweening self-importance.

Artists who were puzzled by the demands of socialist realism were helped out by the guiding principle of *partiinost*, or allegiance to the Communist Party. They could always turn to Party ideologues for advice on aesthetic matters, and the Party itself took a fatherly interest in the problems of artists: it even made room for some of them in prison camps. The aftermath of the Second World War, which the Russians call the Great Patriotic War, brought no respite. In 1946 Stalin's cultural chief, Zhdanov, began to implement a series of ultra-repressive measures, including the closure of museums displaying

foreign art. In Zhdanov's honour, this bleakest of periods in Russian cultural history is called the *zhdanovshchina*.

The new intimacy between art and politics led to the creation of a class of artists who were in close contact with the political élite. To facilitate this relationship, Stalin eventually created in 1947 an Academy of Arts, which was directly funded by the Government and answerable to the Central Committee of the Party. The Academy was intended to be the ideological bastion of Soviet art, supplanting the Artists' Unions which were deemed unreliable even under Stalin. Its members were, and broadly speaking still are, chosen as much for their ideological soundness as for their artistic merit. They dominate many purchasing committees, the management of museums and the selection of some exhibitions.

The first president of the Academy of Arts was Aleksandr Gerasimov (1881–1963), Stalin's favourite painter. He said of his painting *Stalin and Voroshilov in the Kremlin*, 1938 [Pl. 21], which won him one of four Stalin Prizes (First Class): 'I strove to create representations of the leaders as the embodiment of the might, unity, greatness, unshakeability and certitude of all the nations of our great union on the one hand, and of the might and heroism of the Red Army on the other.' This is a mouthful by any standards. More revealing was a laconic phrase of his: 'Stalin – is victory.' Gerasimov personifies not only a reprehensible quality in artistic life under Stalin, but also the flaw in socialist realism, its basic concept of *partiinost*. This cannot be conditional, only absolute: it can make no distinction between a

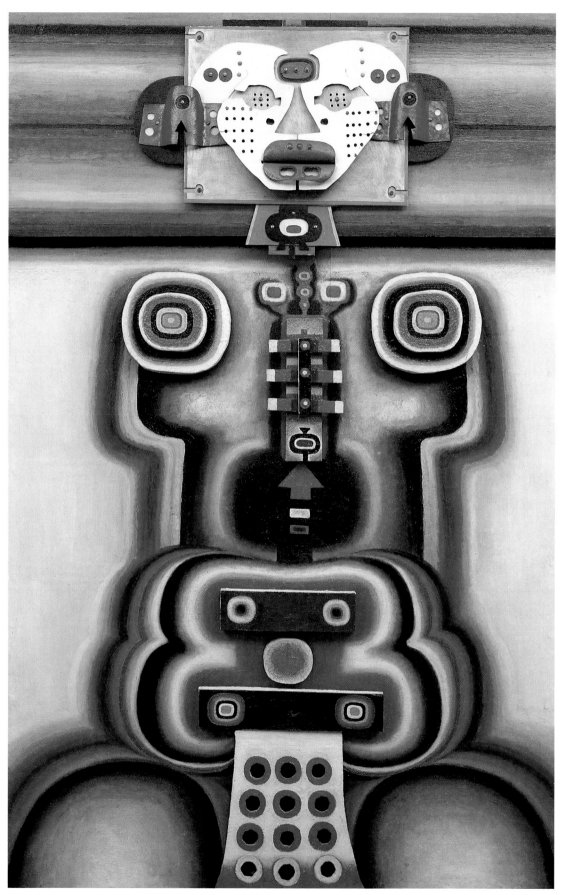

22. VLADIMIR
YANKILEVSKI.
Torso.
1965. Oil, metal and wood,
155.5 × 98 × 28 cm
(61¾ × 38½ × 11 in).
The artist

Stalin and a Gorbachev. By way of a gloss, the novelist Mikhail Sholokhov offered the romantic rubric: 'Each of us writes according to the dictates of his heart, but all our hearts belong to the Party' – but in real life you cannot have your cake and eat it.

Stalin died in 1953. The structure he imposed on the art world, a triumvirate of forces consisting of the Ministry of Culture, the Academy of Arts and the Artists' Unions, is still intact, although an increasing number of independent organizations have sprung up in recent years. The grip he took on the individual's creative spirit was equally decisive. Indeed, the development of Soviet art as a whole since his death might be characterized as an attempt to come to terms with the trauma caused by the Stalinist conception of culture.

23. VIKTOR IVANOV. *Family, 1945.* 1958–64. Oil on canvas, 175 × 257 cm (68¾ × 101⅛ in). State Russian Museum, Leningrad

On Stalin's death, even those artists most ambitious for a career (and the honours to be won) in the official art world reacted against the banal technique and the sycophancy of Stalin's court painters. In Leningrad, for example, the technical freedom of Evsei Moiseenko (1916–88) caused his painting to be regarded as a kind of socialist realist avant-gardism. Other artists, largely in Moscow, began to develop what became known as the 'Severe Style', a movement which dominated critical discussion during the 1960s. They chose subjects of personal rather than overt political significance and dispensed with the obligatory optimism of Stalinist art. *Family, 1945,* for instance, by Viktor Ivanov (born 1924), was criticized for the tragic picture it painted of post-war family life [Pl. 23]. Similarly, an exhibition at Moscow's Manezh Gallery in 1962 led to a number of other practitioners of the Severe Style, such as Pavel Nikonov (born 1930), Nikolai Andronov (born 1929) and Andrei Vasnetsov (born 1924), being harshly attacked by the Communist Party newspaper, *Pravda.* But,

despite the opposition these artists encountered at the start of their careers, they have become the Grand Old Men of official Soviet art – Andrei Vasnetsov, for example, was recently elected President of the USSR Artists' Union. Their work is a more personal, less blatantly hagiographical interpretation of the Communist ideal than was seen under Stalin, often stressing its roots in the Russian soil, in the communal nature of peasant life. They initiated a departure from Stalinist norms which has continued apace from decade to decade, to the point where the concept of socialist realism is nowadays largely inapplicable in critical discussion of contemporary art.

That this should be the case is not due simply to a peaceful process of gradual liberalization. Stalin's death was also followed by the emergence of a more radically non-conformist art than that of the Severe Style. This was the unofficial art movement, so-called because of the immense opposition it faced from the authorities. The complete identification of the Party with a single artistic approach governing both form and content meant that non-conformist art, which differed radically from the norms in terms of style and subject-matter, was viewed with icy logic by the authorities as anti-Soviet. The artists concerned had virtually no access to state-sponsored exhibitions and were subjected to provocations, beatings and the whole panoply of KGB harassment. Understandably, a number chose to emigrate.

To begin with, artists of the unofficial art movement had little in common with one another on a stylistic level. As one artist put it, 'All that unites us is our lack of freedom.' The first coherent manifestation of non-conformism was the informal studio run by Eli Belyutin (born 1925) in Moscow's Arbat district, a traditional haunt of Russian artists, during the late 1950s and early 1960s. Belyutin's initiative ran into a storm at the same Manezh exhibition of 1962 that brought attacks on artists of the Severe Style. According to Belyutin, who still runs a studio with some thirty members of Abramtsevo, a traditional artists' retreat near Moscow, he and other unofficial artists were invited to exhibit as part of a genuine policy of cultural liberalization. Belyutin's controversial belief is that when Mr Khrushchev visited the exhibition his tantrum was not, as is generally believed, occasioned by outrage at the 'formalist' art with which he was confronted, but provoked deliberately by agents working on behalf of Khrushchev's enemies in government. It was a tantrum that reverberated,

signalling the end of the post-Stalin cultural thaw and contributing to Khrushchev's own political downfall. One of the exhibitors at the Manezh at that time was Vladimir Yankilevski (born 1938), who had been taught by Belyutin at the Polygraphic Institute. Yankilevski was one of the first non-conformist artists to find a voice of his own, and has since built a career of remarkable consistency [Pl. 22].

The attempt to repress unofficial art culminated in 1974 in the bulldozing of an informal open-air exhibition in Moscow by KGB agents pretending to be workmen. Because of the international outcry caused by this, a union of graphic artists in 1976 was allowed to set up a small gallery in Malaya Gruzinskaya Street, Moscow, where the exhibiting of work by non-comformist artists was tolerated. But it is only in recent years that the situation of these artists has improved to the point where they can lead a relatively normal existence. That this is now the case is largely thanks to their own struggle. To their efforts can be added the effects of the progressive broadening of attitudes in the official art world, which has closed the aesthetic gap between conformist and non-conformist art; changes in cultural policy initiated under Mr Gorbachev; and, who knows, propaganda pressure from the West.

Despite the fact that the face of exhibitions in Russia has changed considerably in the last few years, the Stalinist structure of the art world survives intact. The ruling triumvirate of organizations: the Ministry of Culture, the Academy of Arts, and the Artists' Unions, are still firmly entrenched, even if criticized and threatened by a stream of alternative proposals.

The Ministry of Culture is responsible for broad questions of cultural policy and in particular for the promotion of Soviet art abroad. Where once it attempted to repress such lions of the unofficial art world as Kabakov and Bulatov, now it markets their work with relish in Europe and America. However, the Ministry is most reluctant to acquire work by these same artists for Russian museums, and from this domestic point of view the concept of unofficial art is not yet redundant. It would sometimes seem that the Ministry intends one art for export, another for internal consumption.

Election to the Academy earns a sinecure income in itself. Academicians still provide the backbone of the salaried arts administration, running the major art schools, officially defining art history and having effective command of most museums. The Academy of Arts is intimately connected with the Government, as Stalin intended. Academicians, for example, have traditionally written the speeches of successive Ministers of Culture. There are only a few hundred members of the Academy, and their conservative views do not reflect those of Russian artists as a whole. The Academy exercises an influence quite disproportionate to the limited perspective of the views it endorses.

Most artists are catered for by the Artists' Unions. The USSR Artists' Union is an umbrella organization which incorporates the separate artistic Unions of each Soviet republic, as well as the Moscow and Leningrad Unions. Membership of a Union is of considerable importance to an artist. It entitles him to a studio, gives him access to materials which may otherwise be impossible to obtain, and above all means he can deem himself a full-time artist. This is an important consideration in a country where failure to have a recognized job can render one guilty of the crime of 'parasitism'.

The Union, by contrast to the Academy, is nominally a voluntary organization. It relies for much of its income not on direct subsidy but on the sale of work by its members, from which it will often take a commission. While not offering a wage to artists, it does enable them to make a modest living by securing commissions from schools, factories, public organizations and so on. The income received from this activity may be supplemented by the sale of work either privately or at exhibitions.

An artist normally gains full Union membership by a complicated process requiring participation in exhibitions of a certain standard and the submission of both creative work and written references. Until the age of thirty-five, artists are allowed to be members of a Youth Section, although this does not imply automatic passage to full membership, which may take place at any age.

Some exhibition halls are Union-run, but not all. In Moscow and Leningrad there are a number of regional exhibition halls and cultural centres for which the local authority is responsible, and these have a conservative or innovative exhibition policy according to the initiative of the director. Other officially recognized organizations – creative Unions, educational institutions, workers' clubs – may also provide exhibition space.

Despite this variety of potential outlets for an artist's work, attempts to set up galleries which are truly independent of control by an official body of some kind have been largely unsuccess-

ful. The first such effort was a grouping of artists and critics called the Hermitage Association, brainchild of the critic Leonid Bazhanov, which for six months or so from the summer of 1987 enjoyed its own premises and mounted a number of significant exhibitions, including a retrospective of unofficial art from the 1950s. At the end of 1987 its accommodation was withdrawn. More recently, the burgeoning of co-operative business enterprises has seemed to offer scope for the establishment of state-independent commercial galleries, and the emergence of a number of these in Moscow would seem to be a logical development.

The widening of opportunity for artists since Mikhail Gorbachev came to power is partly the result of a relaxation of censorship and ideological pressure on the arts, and partly of economic and social initiatives. A tremendous sense of excitement and urgency has been generated. Russian artists are aware that they are witnessing a crucial period in the history of their country. In a way which echoes the heady first decades of the twentieth century, they now often sally forth to do cultural battle in hastily assembled groups, armed with a formidable manifesto. Overall, the agenda is set for an officially sanctioned reorganization of the art world, with an acknowledged pluralism of styles and groupings. However, it would be wrong to underestimate the antagonism which such a prospect arouses. There is no Liberal Tradition in Russia, no real ethic of tolerance. The Russians' passionate identification of art with the great issues of human existence means that any truce favouring pluralism is likely to be an uneasy one.

ONE

MY COUNTRY, 'TIS OF THEE ...

Socialist realism today

The death of Stalin in 1953, undiscovered for half a day because none of his entourage dared enter the bedroom unbidden, was followed swiftly by the dramatic arrest and execution of his henchman, KGB chief Lavrenti Beria. Beria attempted to pull out a gun in the Politburo meeting which voted for his arrest, and was shot soon afterwards, still pleading for his life. These violent events may have acted as a kind of emotional purgation for the inner sanctum of the Communist Party after the murderous pressures of the Stalinist era, but for Russian artists there was, at first, little apparent respite in the *zhdanovshchina*. Not until 1956 was Stalin explicitly denounced by the Party leadership, and then only in a secret speech by Khrushchev to the Party Central Committee. But unpublished though it was in the Soviet Union, news of the speech began to circulate among the intelligentsia and to influence the artistic community.

One effect was to prompt the first stirring of the unofficial art movement, which rejected the creed of socialist realism outright; another was to compel those artists who continued to work in the socialist realist tradition to rethink the hackneyed themes and banal style of Stalin's time. This latter group, whose response was to instil the paradoxical concept of avant-gardism into socialist realism, today occupies a considerable position in the official Soviet art world.

Viktor Ivanov is prominent among these artists. His experience is shared by many of his contemporaries. He attended the Surikov Institute in the late 1940s, where his diploma work was called *Stalin, Educator of Military Leaders*, a theme chosen for him by the Institute. During the 1950s, however, Ivanov became disillusioned with the demand made upon art to glorify the State and its leaders; he saw that demand as a perversion of the true task of socialist realism. Instead he turned to themes of personal significance which linked his experience to that of the Russian people as a whole. In 1958 he began the series of works devoted to the inhabitants, often the peasants, of Ryazan, which has occupied him ever since [Pl. 24].

Ivanov's return to his Russian roots entailed a reworking not only of content but of language. He rejected the photographic realism encouraged in art schools and *de rigueur* among Stalin's favourites, adopting instead a simplified, monumental manner. This was christened the 'Severe Style' by Aleksandr Kamenski, an art critic who perceived a similar tendency in the work of a number of young artists at the time, prominent among them being not only Ivanov but also Pavel Nikonov, Nikolai Andronov and the current president of the USSR Artists' Union, Andrei Vasnetsov. The austere sixteenth-century church murals of Theophanes the Greek and Dionysius, great religious painters in the Byzantine tradition, were one influence on their work. Others were the painting of the Italian, Renato Guttuso, and, more broadly, neo-realism in the cinema together with the whole cultural ambience of post-war Italy. Italy's attempt to reinvigorate itself after the catastrophes of war and Fascism was something with which Russians, who had endured in some ways the same

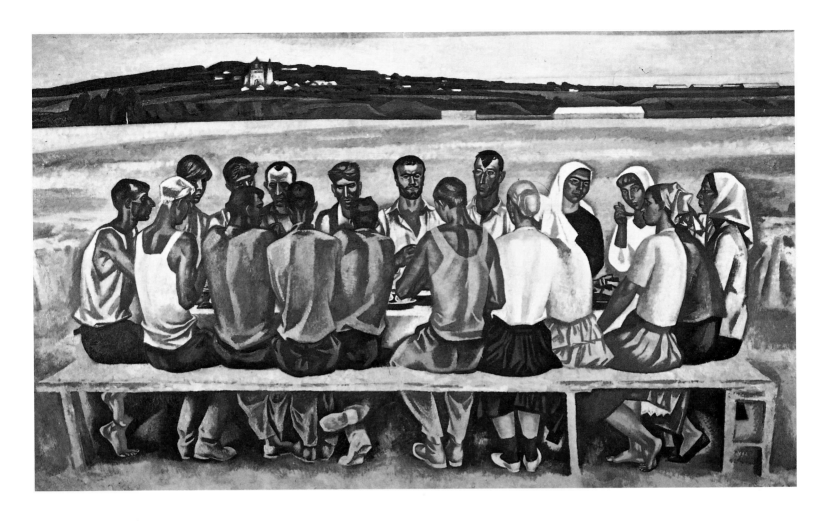

24. VIKTOR IVANOV.
Under a Peaceful Sky.
1982. Oil on canvas,
195 × 357 cm
(76¾ × 140 in). Ministry
of Culture, Moscow

sufferings, could sympathize. In Ivanov's case one can add the influence of the Wanderers, and in particular of Surikov, who liked to tackle his social themes on the same heroic scale sometimes favoured by Ivanov, and with the same workaday brushwork, which seems to accord an aesthetic value to sheer functionality.

Although Ivanov's work is a celebration of Russian life and focuses on ideas like the nobility of labour, which are dear to Communism and thus to socialist realism, his *œuvre* achieves an important reinterpretation of earlier standards. His optimism is not the unalloyed Stalinist version, but one weighted always with the recognition of tragedy as an inevitable, even necessary, component of life. To see life in this way conflicts with the naïve view of steady progress towards universal happiness. This attitude has caused repeated criticism of Ivanov's work over the years. He does not interpret the Communist ideal in terms of Utopia. Rather, he stresses something more atavistic – the need to preserve the communal and ritualistic nature of Russian life.

Tair Salakhov (born 1928) puts a less uncompromising face on the Severe Style. He eschews the mechanical brushwork of Ivanov in favour of the virtuoso manner. He practises an ascetic style of *belle-peinture* indebted to Deineka. This pleasure in the display of technical accomplishment is echoed, on another level, in Salakhov's characteristic approach to the portrayal of labour. He rarely depicts people actually at work, but usually in that state of grace resulting from work just performed. This is a shift of focus away from the Stalinist view, where bliss is seen to occur in the execution of work itself. Salakhov has not ceased to idealize work, but locates this ideal in the realm of pure contemplation.

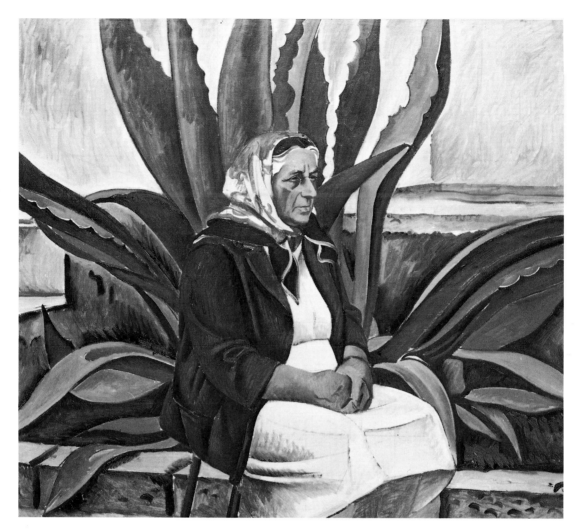

25. TAIR SALAKHOV.
Portrait of the Artist's Mother.
1980. Oil on canvas,
90 × 100 cm
(35½ × 39⅜ in).
State Tretyakov
Gallery, Moscow

Salakhov has also built a considerable career as a portrait painter. Portraiture has occupied an important position in the tradition of Russian realism ever since, in the late seventeenth and early eighteenth centuries, it provided the most congenial genre in which to effect the transition from icon painting to academism. What separates the Russian from the European tradition is that in Europe there is a striving towards the individuality of the sitter, while in Russia there is an attempt to express what is typical or universal in the sitter. This may involve the suppression of details fascinating to a Western artist. Salakhov's subjects have included a number of leading public figures – in particular, composers and poets. Portraits of his family are more heartfelt, but even the tenderness which he shows in numerous pictures of his mother and daughter is not devoid of a classical severity [Pl. 25].

Salakhov is an Azerbaijani by birth, but he lives and works in Moscow, which is the cultural epicentre not only of Russia, but of the Soviet Union. He still contrives to be productive in spite of considerable responsibilities as First Secretary of the Artists' Union and head of a studio at the Surikov Institute. It is a particular feature of the Russian art world that its administrative structure (for example, the Artists' Union itself) is often controlled by artists rather than career administrators. While such an arrangement may appear advantageous to artists in some respects, it has the paradoxical result that the reward for artistic achievement can be elevation to the pinnacles of bureaucracy.

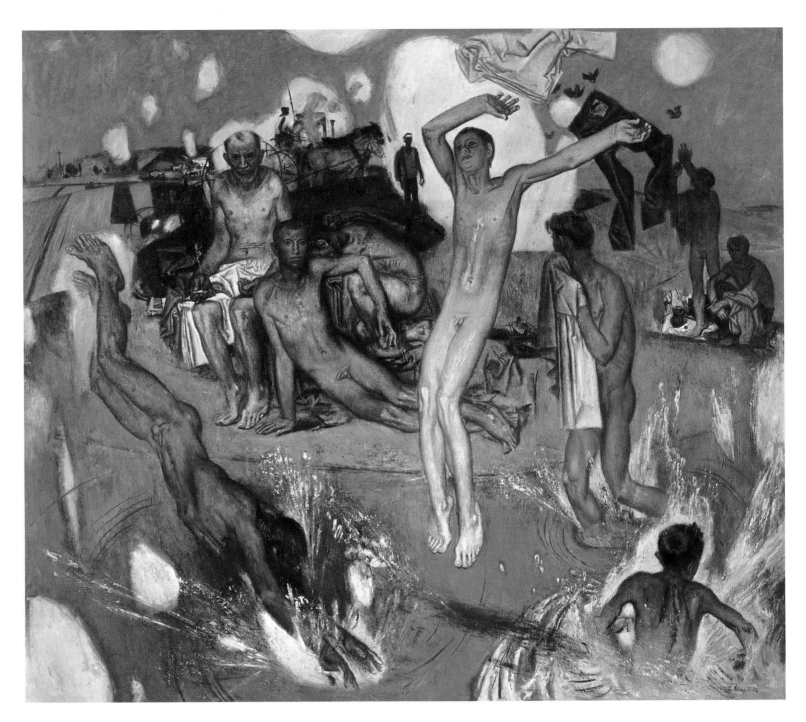

26. EVSEI MOISEENKO.
August.
1980. Oil on canvas,
190 × 220 cm (75 × 86½ in).
Ministry of Culture, USSR

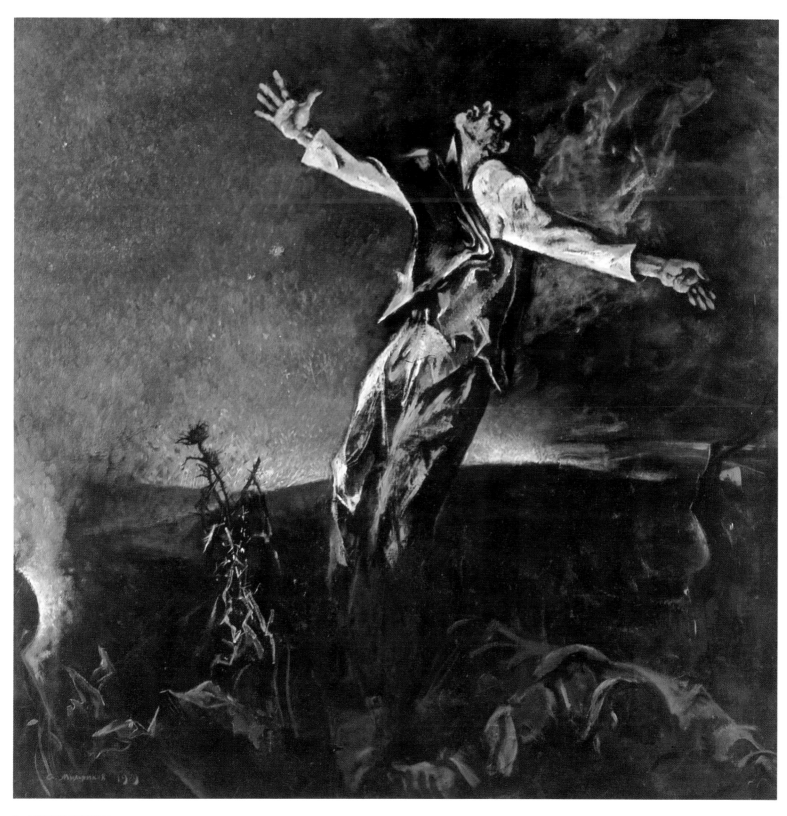

27. ANDREI MYLNIKOV.
Death of Lorca (detail of Plate 29)

The concentration of artists in Moscow has alarmed the Government to such an extent that it has undertaken various schemes, such as the construction of a new art school in Siberia, in order to woo artists away into the cultural backwoods. The only Russian city which today can be mentioned in the same breath as Moscow as an artistic centre is Leningrad, which continues to maintain a distinct cultural identity. Artists and critics often characterize the difference between the post-war schools of official painting in Moscow and Leningrad in terms of an opposition between a painterly and a graphic approach to making pictures. A comparison between the work of, say, Viktor Ivanov and the late Evsei Moiseenko, a Leningrad-based artist of roughly the same generation, bears this out. Moiseenko's stress on the telling detail and the use of line and tone to emphasize contour differs from Ivanov's less inflected technique, which is more concerned with broad forms and subdued harmonies of tone and colour.

As a young artist in the 1950s, Moiseenko was considered, like Ivanov, an avant-gardist within socialist realism, although in Moiseenko's case this was more for the freedom of his technique than for his approach to subject-matter. In particular, the still lifes that he painted throughout his career show the influence of Cézanne and the twentieth-century School of Paris, influences which were considered distinctly controversial in the years immediately after the war. Nevertheless, like the other leading official artists of his generation, Moiseenko took the traditional themes of socialist realist painting and recast them in the light of his own experience. For example, in a series of paintings executed during the 1960s, he dealt with life during the Second World War. This series, entitled *Mothers and Sisters*, avoided the conventional portrayal of stirring scenes at the Front in favour of the less spectacular sufferings of women not directly involved in combat.

Moiseenko enjoyed melodrama, which is exemplified in a theatrical painting of the dead Pushkin [Pl. 28]. The great Russian poet – a man who managed, in a way which has become a paradigm of Marxist-Leninist aesthetics, to combine all the eloquence of High Art with the integrity of the vernacular – is borne up by a peasant, stressing the poet's allotted role in the Soviet Pantheon as an authentic voice of the people.

Moiseenko also displayed a particularly sentimental attitude to his own childhood and to youth in general. It is a sentimentality which can, in the guise of a paean to health and beauty, verge on eroticism [Pl. 26]. Moiseenko acknowledged youth as a source of vigour. His own powers were sustained by contact with it, as confirmed by his choice to continue working, even in revered old age, as a teacher at the Repin Institute in Leningrad.

The impressive neo-classical premises of the Repin Institute, formerly the Academy of Arts, are one product of the great process of drawing closer to Europe which took place in Russia in the eighteenth century. Rightly or wrongly, Leningrad still preserves the air of a more urbane, more Western-oriented place than Moscow, home of the Kremlin fortress and of a Church once renowned for its chauvinism. In keeping with this cosmopolitan self-image, Moiseenko repeatedly emphasized, in paintings on classical Greek themes, the way in which his art was rooted in European culture. Similarly, in his painting *Spanish Triptych* [Pl. 29], the Leningrad artist Andrei Mylnikov (born 1919) reveals something of the idiosyncratic way in which Soviet painters have attempted to establish a relationship with Western culture which does not conflict with the precepts of socialist realism.

Mylnikov is a great romantic; the *Spanish Triptych* is his response to the visual drama and moral passion of Spanish art from Velazquez through Goya to Picasso. He worked on the painting for ten years, using Spanish motifs to approach a grand ethical theme. The left-hand panel represents a matador's moment of triumph as a bull is slain; his gesture is intended to convey not only this triumph, but also his realization that he has killed something entirely innocent, a creature which has done nothing to warrant its execution. The right-hand panel [Pl. 27] depicts the death of Federico

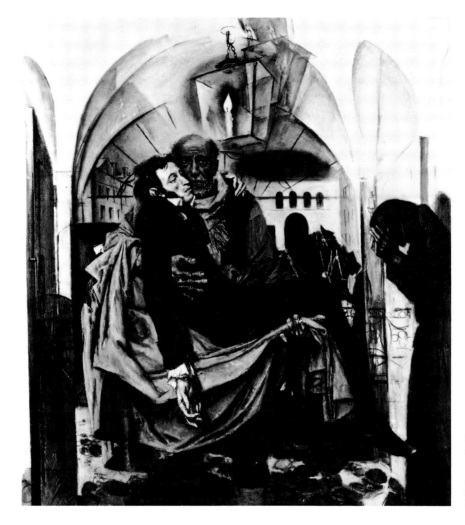

28. EVSEI MOISEENKO.
Death of the Poet.
1985. Oil on canvas,
190 × 140 cm
(74¾ × 55⅛ in).
State Russian Museum,
Leningrad

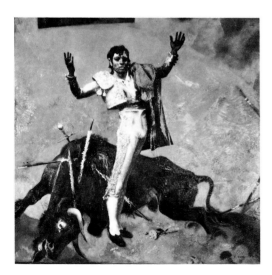

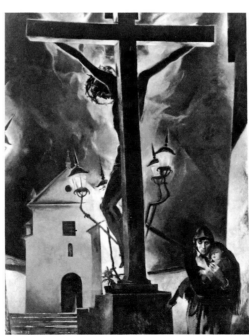

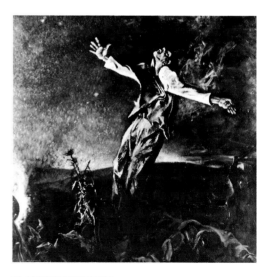

29. ANDREI MYLNIKOV.
Spanish Triptych.
1982. Oil on canvas,
250 × 600 cm (98½ × 236¼ in).
State Tretyakov Gallery,
Moscow

Garcia Lorca, the socialist poet and playwright shot by Spanish Fascists in the 1930s. The Fascist threat, real or imagined, is still a supremely important concept in the USSR, and would certainly be perceived in that way by Mylnikov, who lived through the war. The death of Lorca is thus a symbol for the death of what is best and most noble in mankind at the hands of evil forces. The two ideas expressed in these flanking panels of the triptych, the murder of the innocent and of the good, coalesce in the central image, that of a crucifixion. This is a major theme in Western art, but hightly unconventional in socialist realism, which espouses atheism. True, the emphasis is turned to some extent from the crucified figure to an adjacent mother and child, a potent image in icon painting and a conventional metaphor in socialist realism for future hopes. Mylnikov provides this image of hope on behalf of mankind as a whole, but the terms of its expression are Soviet Socialist.

While artists such as Ivanov, Moiseenko and Mylnikov offer a personal and creative interpretation of socialist realism, there are still artists who glorify uncritically the achievements and attitudes of the State. One of the most prominent of these is Yuri Korolev (born 1929). In his concurrent occupation as director of the Tretyakov Gallery he faced criticism from some quarters for purchasing an excess of his own work for the museum. This is an example of the conflict of interest which must arise when artists themselves control the administrative structure of the art world. A prolific monumental artist, his easel painting can be egregiously formulaic in its sentiments and means of expression [Pl. 30].

However, the evangelic strain inherent in socialist realism is not today confined to the uncomplicated patriotism of Korolev. Mikhail Gorbachev's reforms have brought about a willingness among established artists to confront taboos. The academician Dmitri Zhilinski (born 1928) utilized a major exhibition of the Academy of Arts to display for the first time his painting *The*

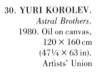

30. **YURI KOROLEV.**
Astral Brothers.
1980. Oil on canvas,
120 × 160 cm
(47¼ × 63 in).
Artists' Union

Year 1937 (PL. 34]. It depicts the arrest of his father by the NKVD, Stalin's secret police, at the height of the pre-war purges. It recalls pictures such as Repin's *Arrest of the Propagandist* (*c*.1880–92) – suggesting a telling comparison of life under Stalin with Tsarist repression. At the bottom of the painting Zhilinski has incorporated the document certifying his father's subsequent rehabilitation. But despite, or perhaps because of, the moral urgency of this *cri de cœur*, it perhaps represents a falling-off in aesthetic quality from the artist's usual rigorously composed, often highly decorative compositions.

Official rehabilitation of the kind given to Zhilinski's father was often a coda, particularly during the 1950s, to the infernal process of an individual's denunciation, disappearance and, not uncommonly, death during Stalin's rule. Cultural figures suffered grievously in this way. Even today, an artist's star can be easily dimmed. Paradoxically, it is the older generation of artists working in the socialist realist tradition, the elders who have for so long dominated the power-structures of the Soviet art world, who feel most threatened. The process of liberalization which has debunked the Brezhnev era, during which their careers were largely made, threatens also to diminish the status accorded to their work. In this sense, socialist realism as a whole faces a crisis. Indeed, the generation represented in this chapter may well prove to be the last to make a contribution to the movement.

TWO

BIG IS BEAUTIFUL

The tradition of monumental art

To a casual visitor to Moscow or Leningrad, the numerous examples of monumental art are the most immediately striking manifestation of Russian art. Monumental art may be described as large-scale, usually permanent and site-specific, intended by and large for public edification. It is a phenomenon which, albeit in a secular State, demonstrates the continuing relevance of the old religious art in Russia today. A revival of interest in the religious tradition took place before the Revolution: Vrubel, for example, was commissioned to restore wall-paintings in St Cyril's, Kiev, in the 1880s. But the Soviet regime, collaterally inspired, when it was not repelled, by the grandiose schemes of the avant-gardists (who once, soon after the Revolution, painted all the trees in the Kremlin an unremovable green colour), recognized and adapted the potential of the monumental for propaganda. This was a logical use of an art form which was in its own right evangelic and didactic. The Moscow metro contains many impressive examples of this brand of public art, and the construction of a new metro station is frequently accompanied by a new commission. Outside the metro, the most overwhelming projects, in terms of their size are the sculptural memorials dedicated to feats of heroism in the Great Patriotic War, rough-hewn edifices sometimes hundreds of feet high.

The origins of monumental sculpture, as opposed to painting, are less easy to pin-point in

31. P. BONDARENKO
(sculptor),
YA. BELOPOLSKI and
F. GAZHEVSKI
(architects),
A. SUDAKOV
(constructor).
*Monument to the First
Cosmonaut of the Planet.*
1980. Titanium,
40 m (131 ft) high.
Gagarin Square, Moscow

32. GREKOV STUDIO.
*Panorama of the Great Battle
on the Volga* (detail).
1985. Oil on canvas,
5 × 25 m (16½ × 82 ft);
detail 5 × 5 m.
Volgograd

Russia itself, although there are precedent examples, such as the eighteenth-century equestrian monument to Peter the Great in Leningrad by the sculptor Falconet. Generally speaking, public sculpture has received a massive fillip in the Soviet period, beginning in 1918 with the publication of Lenin's plan for monumental propaganda. The frequent huge scale and the preference for industrial materials (concrete or stainless steel, rather than the more conventional stone or bronze) suggest that it contains a sublimated response to the Communist glorification of technical achievement, a reverberation of massive undertakings such as the building of the Dnepr Dam in the 1930s, or the space exploration programme which began in the 1950s [Pl. 31].

An enduring institution in the field of monumental art which explicitly serves the State is the Grekov Studio. This is a school of military painting, founded in 1934 and named in honour of the battle painter Mitrofan Grekov (1882–1934), who rode with the Red Army cavalry during the post-Revolutionary civil war and who later glorified its achievements in art. The Grekov Studio is run today by the Red Army itself. Its artists are often involved in long-term collaborative projects on a huge scale. Notable among these are the *dioramy*, sequences of massive narrative paintings, usually depicting military triumphs [Pl. 32]. These stirring scenes, as it were the *ne plus ultra* of *Boys' Own Paper* illustration, keep a patriotic flame burning in museums all over Russia.

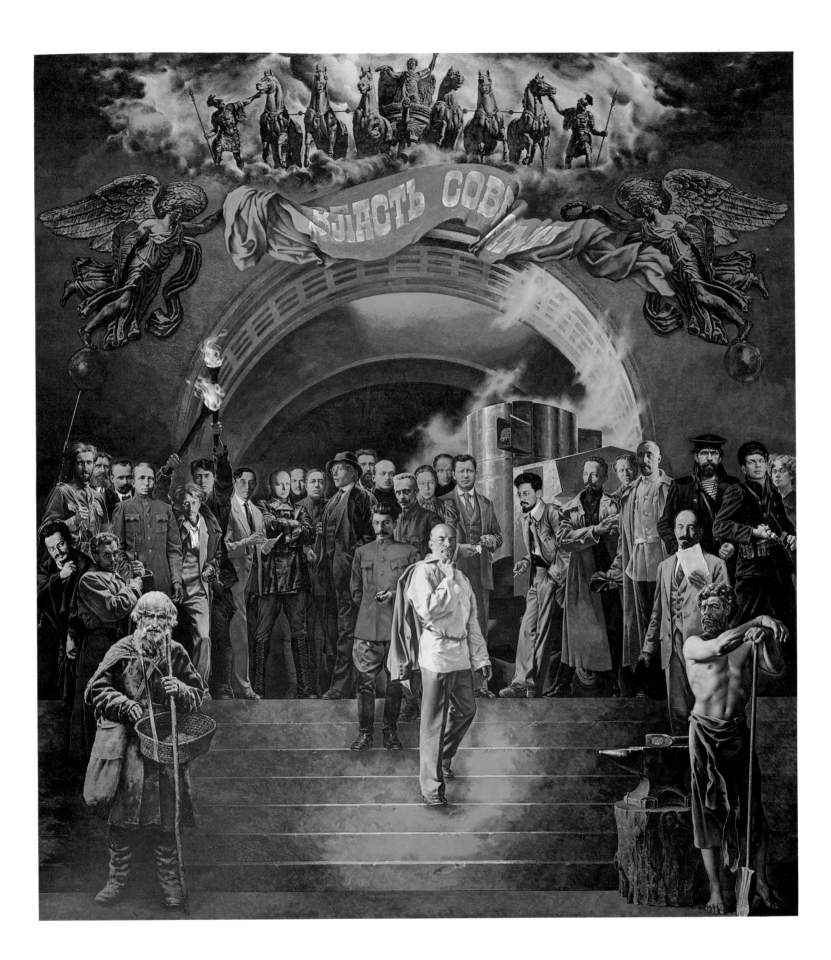

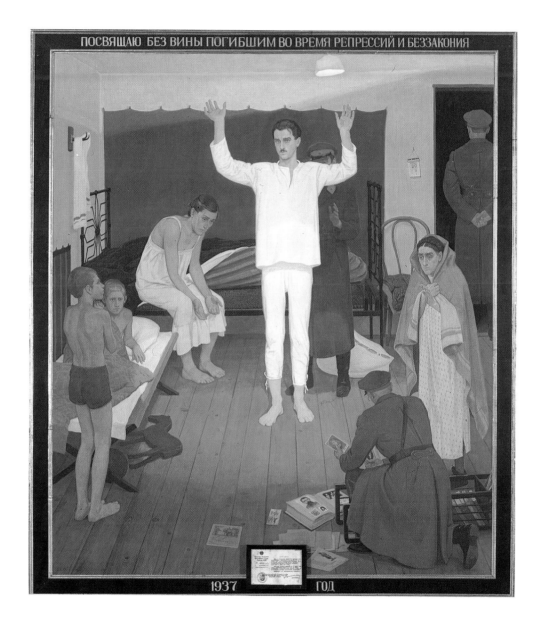

34. **DMITRI ZHILINSKI**. *The Year 1937*. 1987. Tempera, 220 × 160 cm (86½ × 63 in).
State Tretyakov Gallery, Moscow

'Dedicated to those who died without guilt in the time of repression and lawlessness.'

33. **SERGEI PRISEKIN**. *All Power to the Soviets*. 1988.
Oil on canvas, 450 × 400 cm (177⅛ × 157½ in).
Soviet Army Museum, Moscow

Monumental art usually entails collaborative effort, and this is clearly a major justification for the existence of the Grekov Studio. However, artists working with its patronage are often involved in individual projects, carrying out paintings and sculptures with military or even more emphatically State-oriented themes. One remarkable recent example of individual work by a member of the Studio is *All Power to the Soviets* [Pl. 33] by Sergei Prisekin (born 1958).

Prisekin's private creative work often has a self-consciously archaic quality, evoking in meticulous portraits the paintings of Dürer and artists of the Northern European Renaissance. *All Power to the Soviets* – the phrase was one of the first slogans of the October Revolution – is different. Prisekin has given it the brazen finish and melodramatic ambience of a film poster for an early Hollywood epic. This populist note is not misplaced. It is a painting which aims to educate ordinary citizens in the obscured or forgotten history of their own country, and depicts the members of the Revolutionary Committee in Petrograd in 1917. Lenin, in the white of the saviour, advances towards the viewer down seven steps representing seven decades of Soviet power. Behind him hovers Stalin, like a sinister lounge-lizard in a blood-red shirt; and to one side Trotsky, in a funereal black recalling his assassination with an ice-pick, strains to be seen. Most important of all, the picture represents a host of other figures, nearly all of them virtually unknown to the average Russian, who were a motive force in the Revolution and subsequently perished in Stalin's purges.

The painting is exhibited with a key giving the names of everyone portrayed. Prisekin, who researched his picture for three years before painting it, educating himself in the history he had never been taught at school, had the avowed aim of making his viewers, stimulated by the sight of unknown faces with half-remembered names, engage in a similar process of discovery. *All Power to the Soviets* is a canvas which by its very size insists on a public role. It demonstrates a healthy inflection afforded by the spirit of Gorbachev's reforms to the inveterate didacticism of Russian monumental art.

By no means all monumental art is so solemn. Students in departments of monumental painting, who often spend their summers on organized trips, copying the old religious wall-paintings in remote places such as the Ferapont Monastery near Vologda, cannot fail to be struck by the decorative verve of the mural ensembles, and by the vigour of their execution, which is a world away from the turgid academic style encouraged by the Grekov Studio. When Russian monumental art chooses not to proselytize it can exploit the decorative impulse and become instead a vehicle for liberating fantasy. Thus, paradoxically, both this decorative escapist art and the dour evangelism of a socialist realist approach have a common root in the old religious art, with its promise of a better world regulated by saints and angels.

Angelic creatures, flying women who perhaps recall Margarita, heroine of Bulgakov's novel, *The Master and Margarita*, and hint similarly at the anarchic liberating power of sex, are a feature of the work of Boris Milyukov (born 1917), a monumental artist and painter [Pl. 38]. He, of the older generation of Russian artists, best exemplifies this tendency towards fantasy. Milyukov was taught in the studio of Aleksandr Deineka, whose mosaics in the Moscow metro are one of its glories. From Deineka, Milyukov has taken a lightness of touch, compositional wit, and a feeling for the kind of stylistic synthesis which characterized the work of the *OSt* artists in the 1920s. Milyukov evinces a nostalgia for those idealistic, open-minded times, when the attempt was made to link the formal advances of modernism with subject-matter relevant to the new Soviet State. His work has often been opposed because of the unconstrained quality of his imagination and the freedom of his technique from the artistic norms laid down for the generation brought up under Stalin. One of his earliest commissions, in 1953, was for a pavilion of the exhibition in the VDNKh Park in Moscow devoted to Soviet economic achievement, a project which marked the final fling of Stalinist self-aggrandisement. Perhaps it reflects the difficulties of a career in which his talent has had an excessive

struggle for recognition that Milyukov's easel-paintings, which use a restrained palette where blue predominates, are so often self-deprecatory and tinged with melancholy [Pl. 36].

A nostalgia for the 1920s and the Leninist era in art also pervades the monumental work of an artist much younger than Milyukov, Ivan Lubennikov (born 1951). His public art often uses a stark vocabulary indebted to constructivism. This is apparent in his contribution to the Soviet section of the international memorial in the Auschwitz concentration camp. This installation, which he carried out in collaboration with the architect Aleksandr Skokan, exploits dark cramped corridors, shuttered windows and overlapping, spatially-disorienting grid-structures to try to provide a suitably tragic and disturbing monument [Pl. 35].

 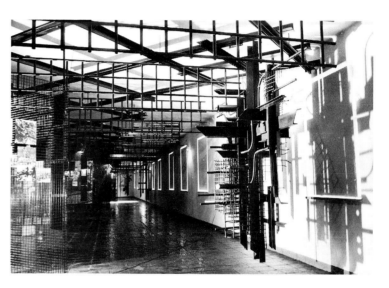

In a way which perhaps signifies the different demands made on a Soviet artist in his public and private life, the severity of Lubennikov's monumental art contrasts curiously with the simple pleasure offered by his easel-painting [Pl. 37]. This, too, is nostalgic in the pictorial language it uses. Although, like Milyukov, Lubennikov acknowledges the influence of the *OSt* painters, his painting seems indebted above all to the School of Paris at the start of the twentieth century, to Picasso and Modigliani, but especially, perhaps, to the Matisse of the mature Fauve period before World War I – a period better represented in Russian museums than anywhere else in the world.

35. IVAN LUBENNIKOV and ALEKSANDR SKOKAN. Soviet Memorial Pavilion at Auschwitz Concentration Camp, Poland. 1985–6

That Lubennikov should evoke a quasi-Parisian idyll, a world of *luxe, calme et volupté* in which French artists have themselves long since stopped believing, is a measure of the force which the legend of the School of Paris still has for Russian artists. It was flourishing at the one time when Russian art was able to play a significant role in European culture as a whole. Lubennikov's paintings suggest the need, in the greyness of the Russian daily round, for a haven of respite.

If, for Lubennikov, painting is Matisse's 'comfortable armchair', then in the case of Irina Lavrova and Igor Pchelnikov (both born 1931) it is maybe the dream they send us when, having sat in the armchair, we doze off. Lavrova and Pchelnikov have collaborated on a number of monumental projects [Pl. 39]. These are characterized by an interplay between sculptural form and architectural space on the one hand, and pictorial illusion on the other, creating a spatial environment of dream-like ambiguity, frequently reinforced by the use of fairy-tale motifs. Pchelnikov in particular likes to set up rhyming relationships between the human figure and architectural elements, the one ever on the verge of transforming into the other. In the complex metaphors of architecture, evoking the human figure and quoting the enduring classical world of art and beauty, Pchelnikov discovers a particular richness.

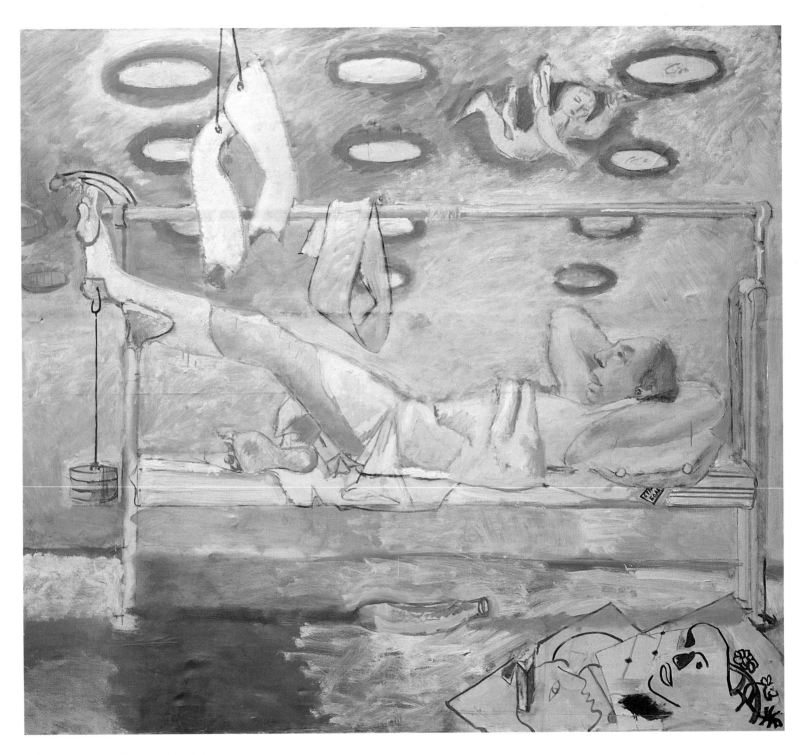

36. BORIS MILYUKOV. *Self-Portrait in Hospital*.
Oil on canvas, 140 × 160 cm (55⅛ × 63 in).
The artist

37. IVAN LUBENNIKOV. *After the Bath.* 1986.
Oil on canvas, 100 × 120 cm (39⅜ × 47¼ in).
Studio Marconi, Milan

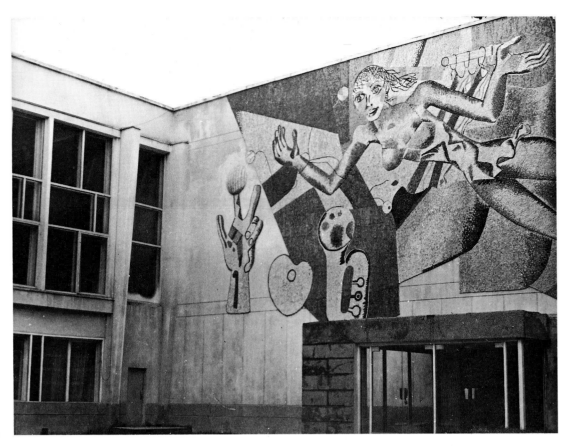

There is an element of sheer playfulness in all this for which the two artists may be indebted to their early years spent as illustrators of children's books and designers of interiors for children's festivals. However, the concept of play, as understood by Lavrova and Pchelnikov, does not simply imply formal manipulation: it is elevated to the status of a romantic principle. The recurring subjects of their monumental work – musicians and actors, in whose professions work and play overlap – evoke a world in which oppositions of this kind (work and play, action and thought, life and art) are resolved into a harmony.

This same yearning for a harmonic resolution of life's problems pervades Lavrova's canvases [Pl. 41]. While Pchelnikov often uses easel-painting as a testing-ground in which to explore structural ideas relevant to monumental art [Pl. 40], Lavrova paints subjects which insist on a creative accord between people – mother and children, artist and model, family scenes in the countryside, dances. Her work, while inspiring reverie, expresses a kind of social idealism of the traditional, explicitly communal, Russian kind.

Lavrova and Pchelnikov jointly represent monumental art arising from a feeling of joy in existence, which is as far removed from the brute evangelism of the Grekov Studio as it is possible to get. The one seems almost deliberately opposed to the other. Among younger artists, however, the lines of this confrontation are often redrawn. Sergei Shutov (born 1955) is a monumental artist and painter who combines a social message with a delight in decoration for its own sake. The extreme ethical sobriety which pervades attitudes to form and content in the Russian art world makes such a delight in decoration a social statement directed against moral austerity.

Shutov's public art consists of installations of a temporary kind, tied to significant events in the cultural calendar. The first showing of the film *ASSA* in 1988, which told of large-scale corruption in the Brezhnev era, was one such event. The showing took place in the MELZ Palace of Culture in

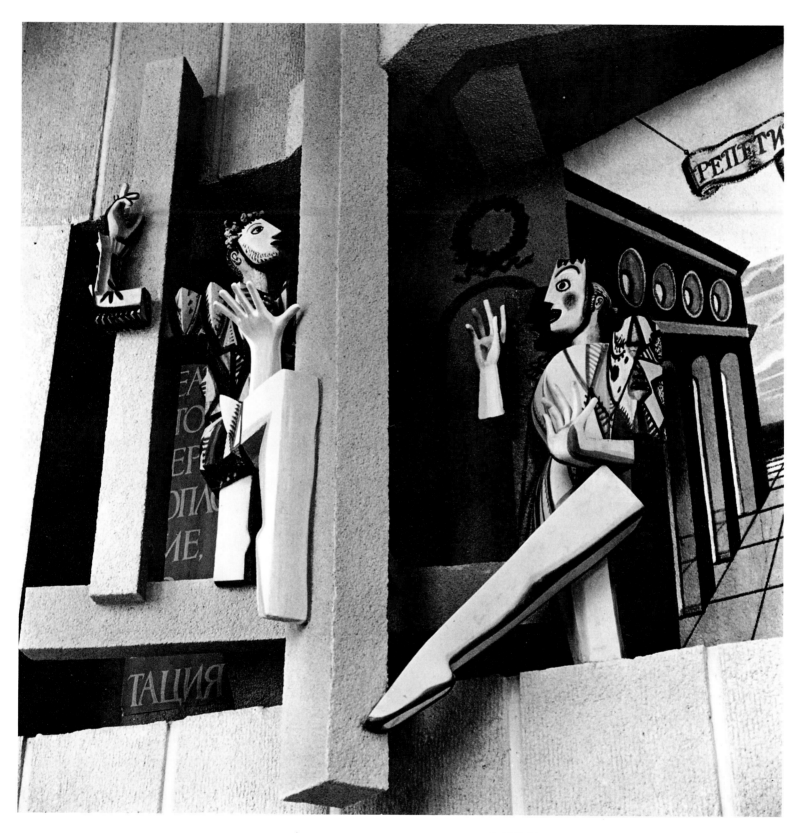

39. **IGOR PCHELNIKOV** and **IRINA LAVROVA.** *Rehearsal in Masks.* 1985.
Concrete, plaster and paint, 200 × 300 × 60 cm (78¾ × 118⅛ × 23⅝ in).
Detail of relief decoration on interior wall of the Drama Theatre, Grodno

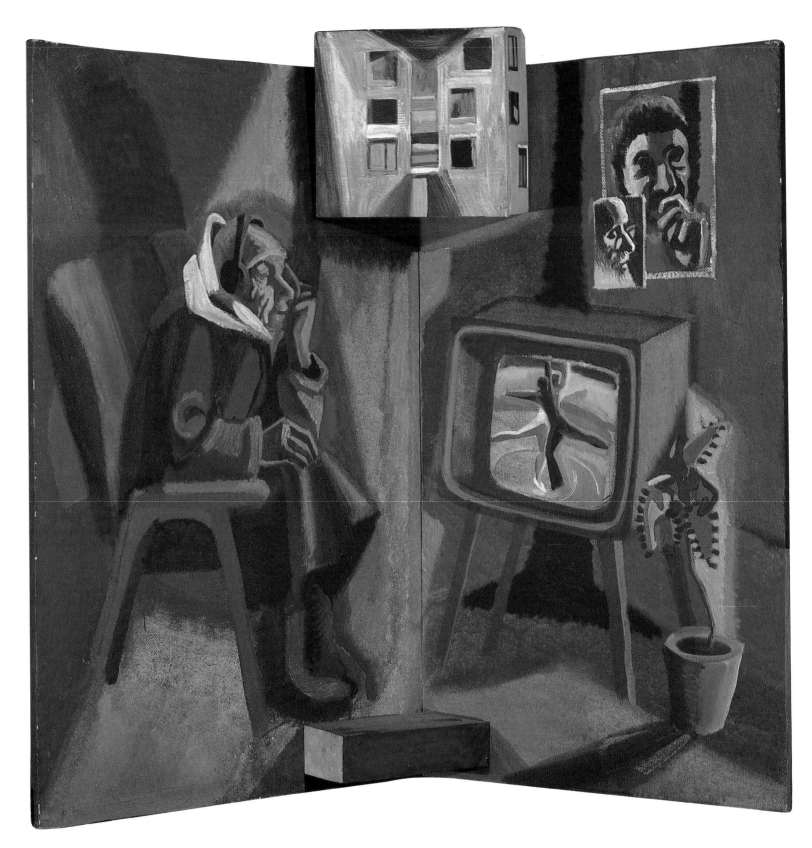

40. IGOR PCHELNIKOV. *Portrait of the Artist's Mother*. 1986.
Tempera on wood, 90 × 90 × 37 cm (35⅛ × 35⅛ × 14⅝ in).
The artist

41. **IRINA LAVROVA**. *Agreement*. 1988.
Oil on canvas, 60 × 65 cm (23⅜ × 25⅜ in).
The artist

Moscow, an archetypal piece of grandiose Stalinist neo-classicism, and was accompanied by an exhibition, fashion shows and rock concerts. Shutov's installation, devised in collaboration with the architect Yuri Avvakumov, satirized the imperial metaphors of the Stalinist architecture. Pillars were erected which had as capitals not hammer-and-sickle emblems perched on acanthus leaves, but wire baskets containing the limbs of broken dolls [Pl. 42]. The self-aggrandisement of the Stalinist era was replaced by an image of its murderous achievements.

Shutov's painting *Fire in Moscow University* [*see* Pl. 1] subjects another Stalinist symbol to ritual destruction. Indeed his work as a whole, not only in its irreverent form and content but also in its informal, improvised nature, is a massive kick in the teeth for Stalinist norms in art. Shutov is the sort of artist who, given the chance, would like to paint the trees in the Kremlin the same indelible green as his avant-garde forebears. He provides convincing evidence that Russian art is emerging from its post-Stalinist straitjacket and regaining some of the variety and exuberance which obtained during the Leninist period. Whether Shutov will eventually be given the opportunity to execute a monumental work for an important permanent site, such as is usually given to more conventional artists, remains to be seen. A new metro station decorated by Shutov would be a perfect memorial to the first flush of the Gorbachev era.

42. SERGEI SHUTOV
and YURI
AVAKUMOV.
Installation.
1988. Mixed media.
MELZ Palace of Culture,
Moscow

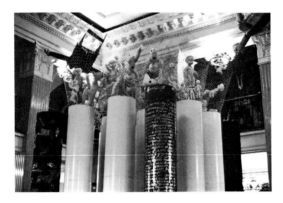

THREE

BREAKING THE MOULD

Figurative painting and
the rejection of socialist realism

An effort to replace the portentous themes of socialist realism with something less didactic became widespread in official Russian art during the 1970s. Young painters felt that the work of the 1960s by artists of the Severe Style had failed to justify its basic premise, which was to give a truthful account of Russian life where Stalinist art had failed. Socialist realism, in any meaningful sense of the phrase, gave way to a more elusive, metaphorical approach, which emphasized an individual's private, as opposed to public, spiritual existence. Many artists, having received an academic training, began to discover themselves only through contact with those aspects of the Russian artistic heritage which had formerly been considered to be beyond the pale of serious consideration – icon painting, folk-art, progressive figurative painting of the 1920s and 1930s – all of which had been neglected since Stalin's time.

In the vanguard of this change of direction in official Russian art was Nataliya Nesterova (born 1944). She received an academic training under Dmitri Zhilinski at the Surikov Institute. Perhaps more than any other artist of her generation she has managed to sublimate that training in her work, though deriving from it a powerful ability to organize pictorial space. Nesterova displays an emotional affinity with a wide range of art and artists previously marginalized by Soviet art history. These stretch from icon painting and Giotto, through nineteenth-century serf portraitists such as Ostrovski, to the Georgian primitive, Pirosmani and the melancholic visionary, Aleksandr Tyshler. Nesterova instinctively shies away from art which is too worldly, as though it were a sign of spiritual exhaustion, and prefers that which seems to spring, unsophisticated, straight from the heart.

Her concern is with the pathos of human existence, the whole web of history, biology, philosophy and religion in which mankind is caught and by which it may seem to be virtually immobilized. She appears to view the common lot as humble and cruelly alienated. In her painting, this is implicit in the unsettling relationship of figures to the surrounding environment, both natural and man-made [Pl. 43]. For Nesterova, architecture is a mysterious reflection of a people's striving. Its successive styles are a key to the unfolding of a nation's fate, monuments to attempts to master that fate: a vast estate of shattered illusions, inhabited by generation after hapless generation, none of which has any hope of putting it into order.

Nesterova recognizes a poetic democracy of the animal, vegetable and mineral, discovering a charged quality in the inanimate world which intensifies our sense of the poignancy of the human condition. In a pictorial space which often has the make-believe appearance of a stage set or puppet theatre, constructed from flats, figures arise that seem no more alive that the inanimate objects which surround them [*see* Pl. 46]. She sometimes stresses this by applying very thick paint to parts, but never all, of a picture. This formal device disrupts any attempted 'suspension of disbelief' and tendency to read it from an anthropocentric point of view. We are led to the conclusion that

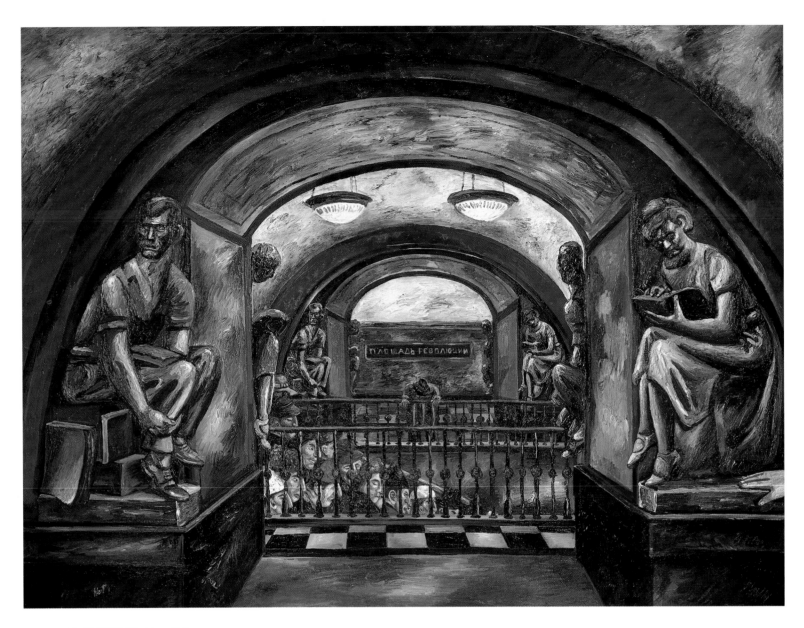

43. NATALIYA NESTEROVA. *Metro.* 1988.
Oil on canvas, 150 × 200 cm (59 × 78¾ in).
Private collection

44. TATYANA NAZARENKO. *Shop window* (right-hand panel of diptych). 1986.
Oil on canvas, 140 × 100 cm (55⅛ × 39⅜ in). The artist

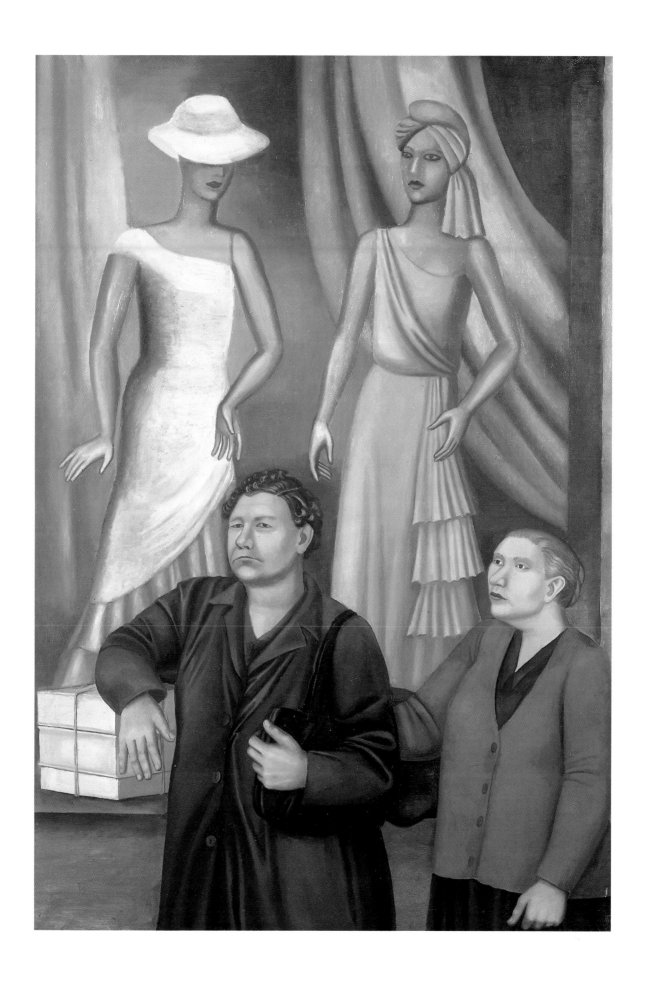

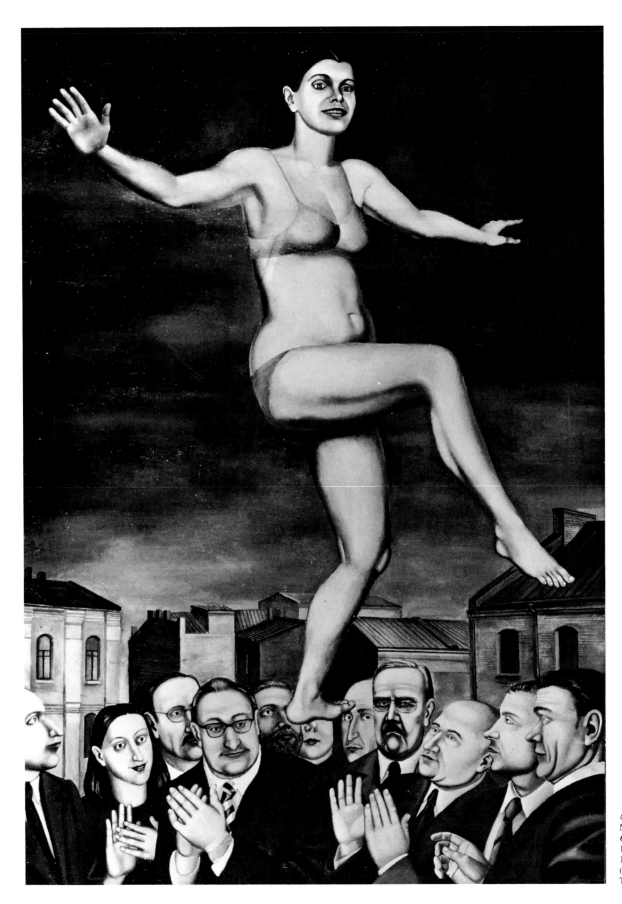

45. TATYANA NAZARENKO.
Circus Girl.
1987. Oil on canvas,
190 × 130 cm
(74¾ × 51⅛ in).
The artist

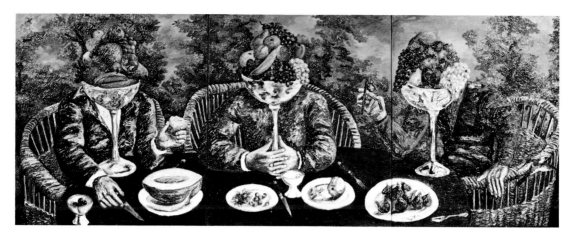

humankind, constantly engaged in the satisfaction of crude needs and appetites, is pitiable when judged by the yardstick of its own spiritual aspirations – a victim, rather than master, of its own desires.

The sinister nature of desire is a theme which recurs in the work of Olga Bulgakova (born 1951). Like Nesterova, she frequently proposes a visual rhyme of the organic with the inorganic, but it is a rhyming not of the texture and consistency of objects, as in Nesterova's work, but of surface shape, in which empty spaces echo the pretensions of solid form. Whereas Nesterova's dramas are played out in the world we know, Bulgakova's inhabit a less public, more equivocal realm. It is that of Gogol's fantastical stories, the artist's studio or, the ultimate home of all her transformations, Bulgakova's own imagination [Pl. 47].

Bulgakova owes the jewel-like colours and enamelled surfaces of her paintings above all to icon painting, and, in common with icon painting, her work appeals to the mind which can embrace irrationality. However, it offers few of the compensatory certitudes of religious art; terror is as much a part of it as reassurance. When the atmosphere of menace recedes in Bulgakova's work, it is often exorcized by the restorative image of a mother and child – fittingly, in view of her indebtedness to icon painting, and characteristically, because she is a Russian.

Tatyana Nazarenko (born 1944) studied with Nesterova under Zhilinski, and seems to have absorbed some of his concern for illustrative detail, while also responding to the directness of expression and capacity for fantasy which abides in folk-art. If the painting of Nesterova and Bulgakova may be broadly described as metaphorical, Nazarenko's work may be seen as allegorical. Bulgakova invites us to dream: Nazarenko invites us to guess at a concrete message. This is underlined by her frequent use of the diptych format, favoured by artists who want to make the viewer think about complex ideas by exploring the conceptual links between different segments of a painting.

During the 1980s a degree of explicit social comment surfaced in Nazarenko's painting, foreshadowing the work of a younger generation of artists [Pl. 44]. Her exploration of the relationship of the individual to social and cultural norms receives it fullest expression in her self-portraits, set against a backdrop of Moscow and populated with objects suggesting a complex, quasi-allegorical interpretation. At other times, her work impinges on what, in the West, would be perceived as a 'feminist' concern, i.e. that of woman's position in society [Pl. 45]. In Nazarenko's case this is not so much an embattled *Weltanschauung* as the product of her sympathy for the plight of ordinary people. While Nesterova evokes this plight in metaphysical terms which suggest that only resignation makes sense, Nazarenko's work implies that, if an effort were made, things could get a little better.

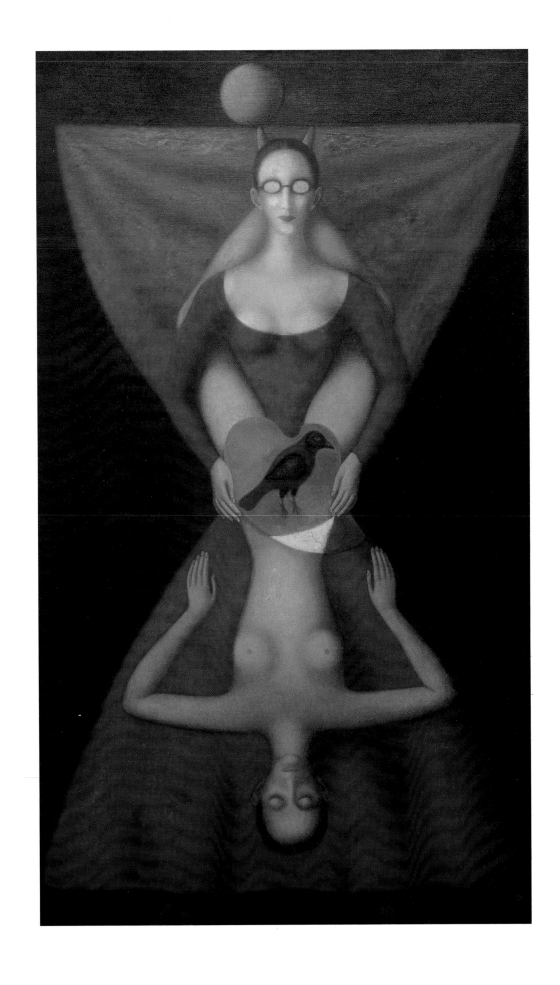

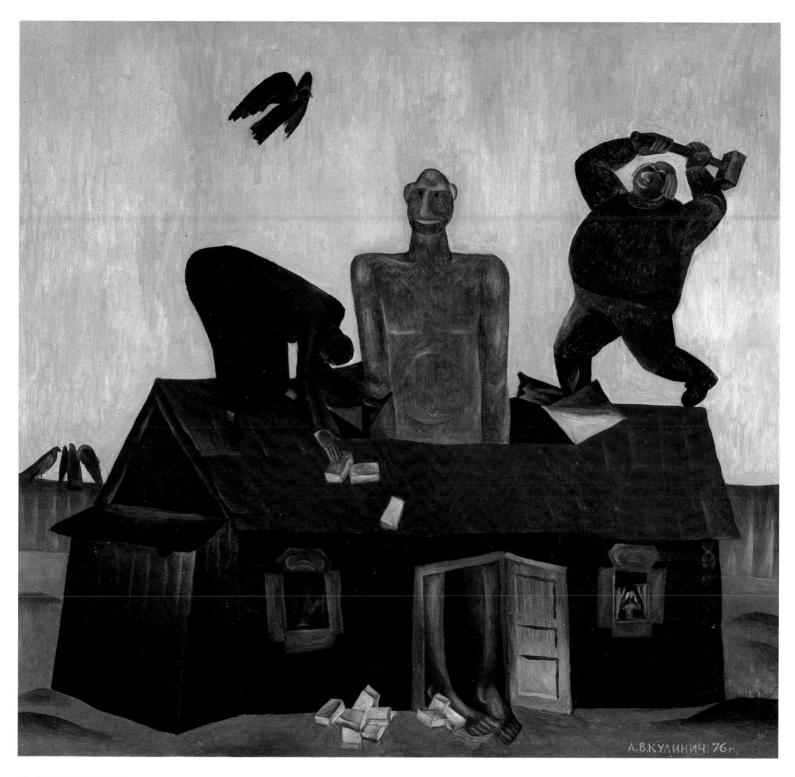

48. ANATOLI KULINICH. *The Sorrows of Old Men.* 1976.
Oil on canvas, 42 × 45 cm (16½ × 17¾ in). The artist

47. OLGA BULGAKOVA. *Transformation.* 1988.
Oil on canvas, 160 × 90 cm (63 × 35⅜ in). The artist

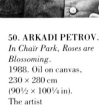

50. ARKADI PETROV.
In Chaïr Park, Roses are Blossoming.
1988. Oil on canvas,
230 × 280 cm
(90½ × 100¼ in).
The artist

49. ARKADI PETROV.
The Pop Star Alla Pugacheva.
1988. Oil on canvas,
180 × 180 cm
(70⅞ × 70⅞ in).
The artist

The work of Arkadi Petrov (born 1940) displays an acute social perception of a different kind. Like Nesterova and Nazarenko, he draws on popular art, in his case on what might be broadly termed Russian kitsch: sugary greetings cards emblazoned with roses, retouched photographic pin-ups, commemorative paraphernalia, idealized portraits of children in Pioneer uniform and so on. It is the kind of art which fills the homes of ordinary people in the Donbass, the mining area where Petrov grew up. Despite his academic training at the Surikov Institute, and consequent exposure to the blandishments of the Moscow artistic intelligentsia, he has remained faithful to the appeal and peculiar, expressive possibilities of this popular art ever since.

Petrov understands the attraction of these images in more than sentimental terms. They represent a world of prosaic happiness which revolves around simple values: love, sex, beauty, marriage, motherhood, the family [Pl. 49]. As Hollywood cinema was aware, these values are never more seductive than when presented in an ineffably banal form. His painting *In Chaïr Park, Roses are Blossoming* (the name of a ballad popular in the Stalinist era) proposes a kind of father-daughter relationship between Stalin, 'the best friend of children', as he was known, and the three innocent and vulnerable young Pioneers [Pl. 50]. This is a polemical proposition of a symbolic kind, based on the extraordinary reverence for the 'Father of the Peoples of East and West' which obtained during the period of his leadership. So strong was Stalin's spell that today not a few of the older generation still hang his photograph on the wall of their homes: experience of the quicksands of life under Stalin does not seem to diminish the sense of security he offered. The fact is that not only under Stalin, but for centuries, the wielding of power by the Russian State has been characterized by a deep, religious paternalism. But Arkadi Petrov is aware of the terror which can masquerade as fatherly love: in the present context of Stalin's widespread vilification, his painting is bitterly ironic.

That ambitious artists should turn to folk-art as a way out of the thickets of academism is an indication of how significant popular art forms are in Russia. They are touchstones for artistic integrity and national tradition in an environment where art is too readily bastardized. (One ironic consequence of this is that any old peasant lady who shows a vestige of artistic talent is liable to find collectors with a speculative glint in their eye beating an entrepreneurial path to her door.)

Nesterova, Nazarenko and Petrov use these forms with discrimination from a sense of their own historical position. They accept the alienation from the roots of popular art that this entails. But there are other artists who enter less critically into this world of folk-myth. For them it represents a world-view which can still function without irony.

Anatoli Kulinich (born 1949) grew up in the countryside in the company of his mother and a ginger cat. After studying at art school in Moscow, he travelled in the undeveloped regions of Siberia and the arctic north; the experience he gained there, combined with memories of his rural childhood, led him to develop a style derived from forms of folk-art [Pl. 48]. Kulinich's work allows free play to all the fantasy inherent in the folk-tales which inspire him, and often expresses the quirky and intransigent religiosity of the peasantry.

Some of the passionate contradictions underlying Russian religious feeling are apparent in the work of Anatoli Slepyshev (born 1932). His expressionist manner, a pure form of *alla prima* painting, recalls the work of artists such as Aleksandr Drevin (1889–1938) who suffered such persecution under Stalin. (Drevin himself died in exile in Altai.) Slepyshev, no less than Nesterova or Petrov, is significant because he renews the value of a neglected artistic heritage. In Slepyshev's work the metaphor of expressionism, its signification of unconstrained emotion, enters into a dialogue with his often religious subject-matter, a dialogue which has a deep, peculiarly Russian resonance.

In a painting, *The Village Easter Procession*, 1861, by Vasili Perov, a leading member of the Wanderers, the clergy are seen emerging, rolling drunk, from an inn to take part in a religious procession. In comparable vein, Slepyshev seems to suggest that piety must exist amid Dionysian chaos, entailing an endless cycle of sin and repentance. There is a profound sense in which the crowd accompanying Christ in Slepyshev's *The Way to Golgotha* [Pl. 52] are involved in a celebration of an ineradicable, primitive kind – a reflection of the pagan rituals still observable in the remote Russian countryside.

The spirit of Russia in all its blessedness and isolation finds expression in the work of Irina Zatulovskaya (born 1954). Although she studied at Moscow's Polygraphic Institute, she perhaps

51. IRINA ZATULOVSKAYA. *Christmas Night.* 1986. Oil on wood, 50 × 80 cm (19⅝ × 31½ in). The artist

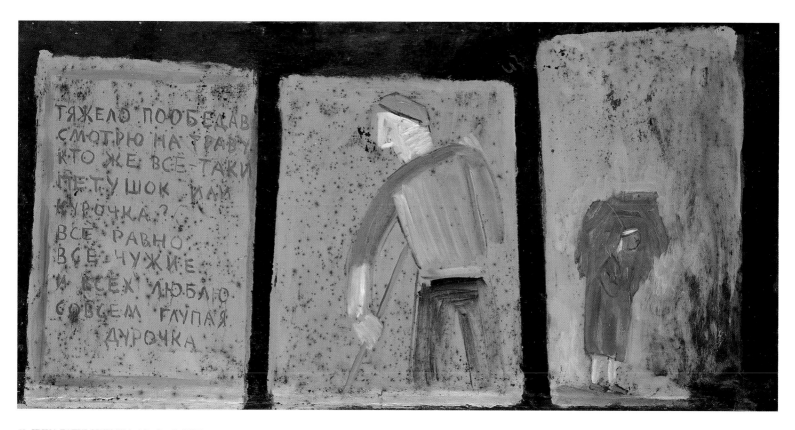

53. IRINA ZATULOVSKAYA. *After Lunch.* 1987.
Oil on metal, 70 × 140 cm (27½ × 55 in). The artist

'After lunching heavily, I am looking at the grass. Who, for all that, is a cock or a hen? It does not
matter, they're all strangers, and I love them all, like a complete idiot woman.'

52. ANATOLI SLEPYSHEV. *The Way to Golgotha.* 1987.
Oil on canvas, 150 × 100 cm (59 × 39⅜ in). The artist

comes closer than any other painter to the state of apparent holy innocence towards which Russian art so often strives. Zatulovskaya's work is not hedged around with the ifs and buts of 'good painting' as understood by academism: she gets to the point in a way that most artists find impossible all their lives. In its directness, her work recalls Larionov's vibrant exploration of the folk-art tradition at the start of the century [Pl. 51].

For all its freshness, Zatulovskaya's art is worldly to an extent that is unusual even among the younger generation of Russian artists. She is as likely to make a painting on a rusty piece of sheet iron as on a new canvas; a picture is as likely to be supported on a welded steel stand, to be viewed from both sides, as it is to hang on the wall. If this means that Zatulovskaya, rather like Malevich, has the superficial air of an *ingénue* who gets it right, then this belies her profoundly thought-out attitude to her art and her life.

After Lunch is painted on metal taken from the roof of one of Russia's oldest cathedrals [Pl. 53]. The painting is thus sanctified in a way which is at once primitive (one thinks of holy relics) and peculiarly contemporary (recalling, for example, Beuys's making a fetish of materials because of their associations). For more than ten years now, Zatulovskaya has been creating a series of books on a rigorous conceptual basis, forming a similar bridge between life and art. They appear one every six months, devoted to ideas and flights of fancy inspired by successive letters of the alphabet. Begun to mark the birth of her daughter, these books have gradually become a collaboration between them. She intends that her daughter shall take responsibility for the books entirely as she grows older. What on one level is a means of communication between mother and daughter, is on another a means of coming to terms with the world. The pictorial images and writing of these books have an intimate relationship to Zatulovskaya's art. The phrases, and sometimes extended texts, which occur in her paintings are by no means fortuitous.

Despite this covert sophistication, her work has a quality of pathos which cannot strike a false note. Of all the younger generation of artists, Zatulovskaya's painting best shows the melancholy, satirical, humane qualities, and the deep religious feelings, which in Russia are intimately bound up with the folk tradition.

THE PAINTERS OF EVERYDAY LIFE
Social themes in the Gorbachev era

The widespread rejection of socialist realism by Russian artists in the 1970s did not entail a rejection of realist painting *per se*. After all, realist art is still the only kind taught in Soviet art schools, and forms the larger part of the Russian artistic heritage of the nineteenth and twentieth centuries. Nor did it imply that painting should no longer be socially engaged. That would have meant disavowal of the Russian artist's missionary vocation. But artists were confronted with the task of developing a new kind of realism, one which would take an uninhibited look at the world, unprejudiced by an aesthetic tied to the interests of the Party.

In contrast to painters such as Nesterova or Slepyshev, the solution for some artists of the 1970s was to adopt a stylistically neutral realism, a gaze on the world which avoided the emphasis on individual authorship entailed by a more painterly approach. Nevertheless, in so far as this echoed the photo-realist movement which originated in the USA, it contained the germ of a social attitude. It suggested a deliberate extension of vision beyond the parochial values of Soviet culture.

The paintings of Andrei Volkov (born 1948) are pervaded by a sense of expectancy, almost of anxiety [Pl. 54]. In his work the Russian capital ceases to be the dead backdrop to glorious events that it so often was in earlier painting. It becomes instead an entity with a life of its own – a life which Volkov does no more than hint at, insisting upon its essential mysteriousness. In this he speaks the truth. Moscow, whose impassive public mien does not betray the tumult of its private passions, is certainly a most secretive city. Volkov's Moscow is virtually deserted, but even when wholly depopulated it is never without traces of human existence. Such traces, merely a lone figure, engage us and prompt us to conjure up poignant images of obscure life in an unknowable city. Of course, Volkov is not in any strict sense a photo-realist. The source for his paintings is usually drawing; and the liveliness and variety of his paint-handling indicate his attachment to traditional artistic values. What he exploits, which is common to photography, is the quality of an impersonal gaze.

By contrast to the essentially traditionalist Volkov, Simen Faibisovich (born 1949) is a painter very much in the mould of American photo-realists. His paintings, with their absolutely uninflected surface, enlivened only by the minute texture of canvas grain, all derive from photographs [Pl. 55]. They offer a detached perspective with none of the quality of sublimated narrative that we find in Volkov. Faibisovich admits a debt, in particular a technical one, to the photo-realism of Estes and other Americans who were shown at the Pushkin Museum in the 1970s. His painting departs from their example not only in its traditional concern for composition, but above all in its deliberate humanism, its interest in people rather than signs and surfaces. In this sense it is predicated, like so much Russian art, on the idea of a dialogue with society; as though a person who had once viewed a painting by Faibisovich might find that it conditioned his view of his fellow citizens.

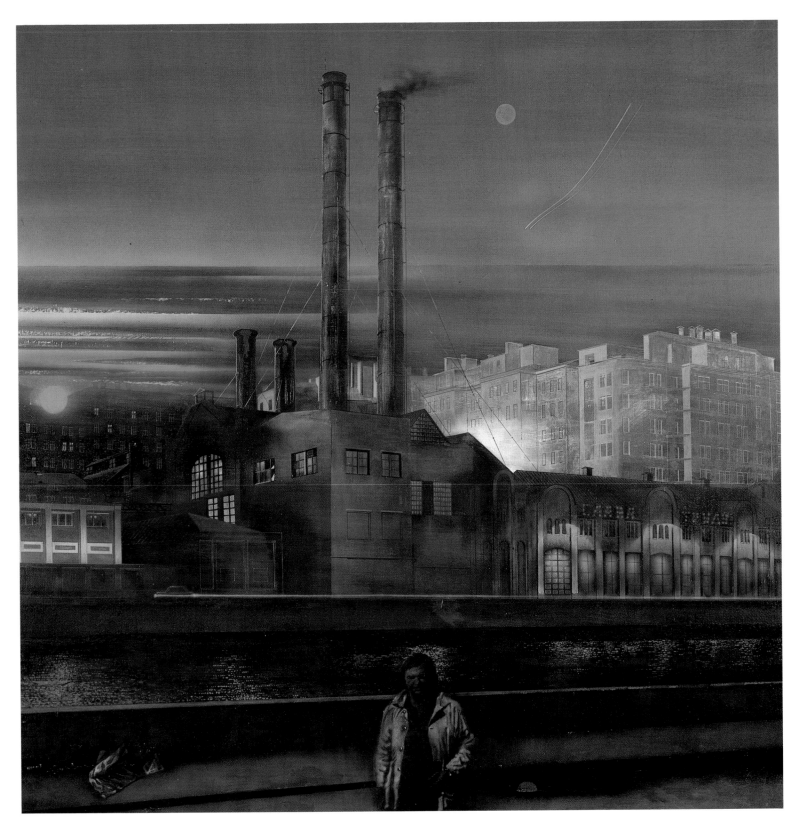

54. ANDREI VOLKOV. *TsLEM.* 1983.
Oil on canvas, 160 × 160 cm (63 × 63 in).
Ministry of Culture, USSR

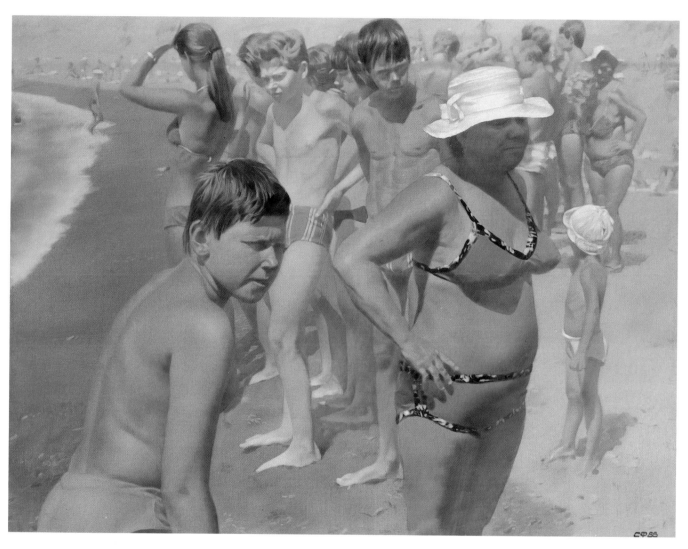

55. SIMEN FAIBISOVICH. *Before Bathing*. 1988.
Oil on canvas, 150 × 200 cm (59 × 78¾ in).
The artist

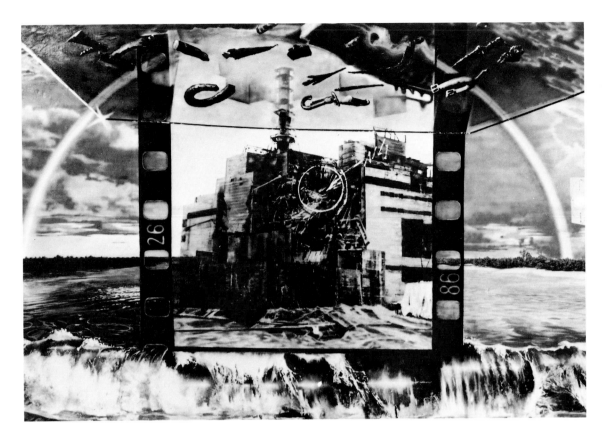

56. SERGEI BAZILEV.
Catastrophe.
1987. Oil on canvas,
200 × 300 cm
(78¾ × 118 in).
State Tretyakov Gallery,
Moscow

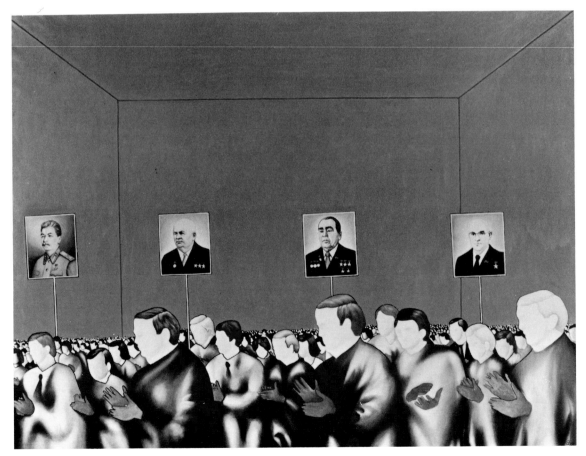

57. ALEKSEI
SUNDUKOV.
*Prolonged and Undiminishing
Applause.*
1987. Oil on canvas,
150 × 200 cm
(50 × 78¾ in). The artist

Faibisovich arrived at his painstaking art by an arduous route, first training as an architect and afterwards, when already a practising architect, working on drawings in the evenings. In those days, he sometimes devoted months to a single one. He finally turned to oil painting at the age of twenty-nine. He deliberately acknowledges the photographic nature of his source material, and this sets him apart from other Russian hyper-realists, who, like Volkov, often work extensively from drawings. It is also a choice with a certain ethical purport. In a drawing, an artist is, in effect, already adopting an attitude to his subject-matter: he is choosing to translate his experience in one way rather than another, according to the style he uses. For a Russian painter, the choice of style is also an ethical decision. This applies not only to big distinctions, such as that between abstraction and figuration, but also to nuances of expression within the practice of realist painting. For example, the dogged paint-handling of an artist like Viktor Ivanov is effectively a statement of belief in the virtue of simple labour, a subject which he often depicts in his paintings.

Faibisovich's refusal to adopt a style, his decision simply to reiterate the photographic image, is a significant choice: it implies that he will not pass judgement on his subject-matter. What, then, is the Soviet viewer, brought up to believe that art has a message, supposed to make of an image of men laughing in the queue for alchohol, or of old ladies sitting waiting for a train, or of a fat woman on a beach? Is it painted in criticism? Or in praise? Faibisovich, no less than an abstract painter, calls into question the tendentious nature of the 'social' role often played by painting in Russia. In his attempt to escape the ideological arena of realism, he has something in common with artists of a more conceptual inclination, such as Erik Bulatov.

Faibisovich is out on a limb as far as Russian realist painters are concerned. They are on the whole unwilling to relinquish the narrative and didactic capabilities of their art. Indeed, a self-conscious engagement with the dramas and controversies of contemporary life is a significant trend in realism of the 1980s. One obvious example of this is the painting *Catastrophe* [Pl. 56] by Sergei Bazilev (born 1952), which approaches the Chernobyl disaster by means of a montage of imagery derived from the media. The revival of interest in great themes after the inward-looking 1970s has been accompanied by a shift away from the obligatory optimism of socialist realism. The new approach has been called social or critical realism by Russian critics who see it as the quintessential mode of expression for the Gorbachev era. All labels are ultimately unsatisfactory, but it is certainly an art which points up flaws in society. Its adherents can be said to have reinterpreted the educative role conventionally ascribed to art in Russia and returned it to the precepts of the Wanderers, who regarded criticism as a prime function.

A favourite subject of the Wanderers, the religious procession in which icons are carried aloft on poles, is evoked in *Prolonged and Undiminishing Applause* [Pl. 57] by Aleksei Sundukov (born 1952). Sundukov's blank-faced (and by implication mindless) crowd carry placards on which are portrayed four Soviet leaders: Stalin, Khrushchev, Brezhnev and Andropov. They are applauding an unseen speaker who is, we assume, Gorbachev, although an alternative reading of Chernenko, the caretaker leader who came between Andropov and Gorbachev, would be legitimate. Sundukov draws a parallel between the crowd in his painting and a crowd of orthodox Christians, inspired not by reason but by unquestioning faith. The people Sundukov depicts will worship all Soviet leaders indiscriminately, making no distinction between Stalin's repressive rule and a more liberal and tolerant regime. Sundukov's picture calls into question the Party as the arbiter of truth and morality. If the Party has a monopoly in this area, we infer, then Stalin's actions could be ethically indistinguishable from those of Gorbachev.

Sundukov's painting clearly goes beyond the parameters established by the Wanderers: it does not just comment, it analyses as well. This same tendency towards social and political analysis is found in his painting *Radiofon* [Pl. 60]. The title is a play on words: it is the brand name of a Soviet

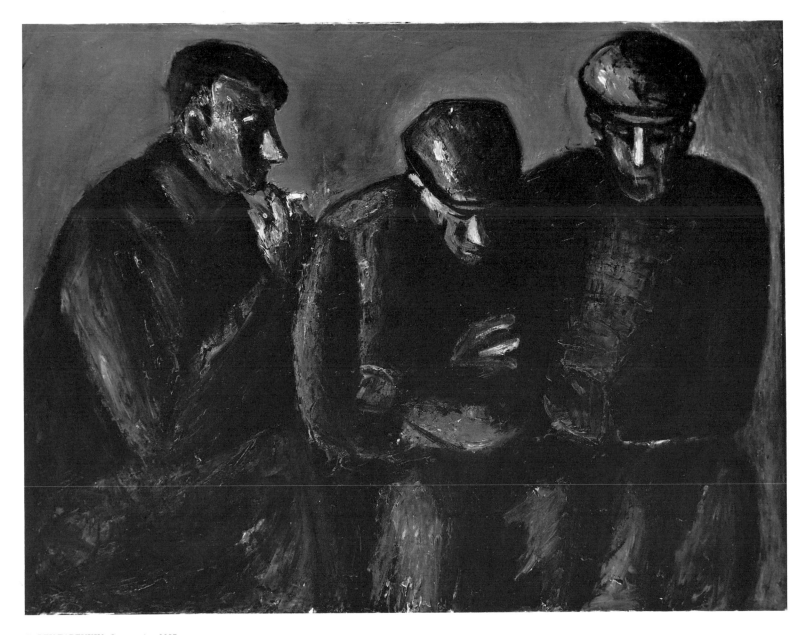

58. LEV TABENKIN. *Conversation*. 1987.
Oil on canvas, 120 × 170 cm (47¼ × 67 in).
The artist

59. LEV TABENKIN. *Eagles*. 1987.
Oil on canvas, 210 × 186 cm (82½ × 73¼ in).
The artist

radio, and the word *fon* also means 'background'. The background in this case is the stream of verbiage that is emitted by the radio and penetrates, in fragments, the mind of the sleeping man. A superficial interpretation of this picture might take it as a metaphor for brainwashing, but this would be a reading prompted by Western prejudice and not borne out by the varied nature of the textual fragments. The sense of the painting is less crude. On one level, it recognizes our common plight, inhabitants of a world saturated with information dying to be communicated. On another, it makes a profound point about the nature of Russian thought which, with its love of proverbs, bureaucratic jargon and stock phrases is ritualized by language.

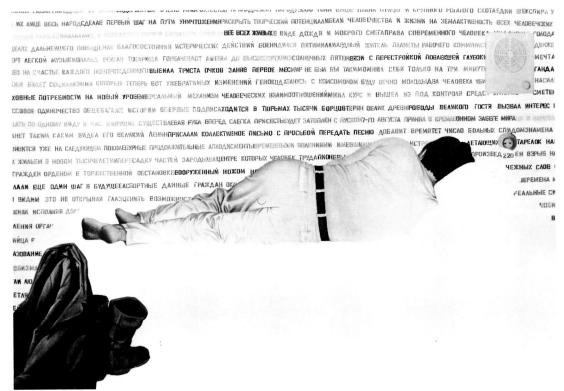

60. ALEKSEI SUNDUKOV.
Radiofon.
1987. Oil on canvas,
100 × 120 cm
(39⅜ × 47¼ in).
Costakis Gallery, Athens

Life in Russia is subjected to a less subtle, but no less resonant critique in the work of a contemporary of Sundukov's, Maksim Kantor (born 1957). One source for his figurative style is German expressionism of the early twentieth century, and there are echoes of the work of contemporary expressionists, such as Anselm Kiefer, in the surfaces of his paintings. These are often built up into shallow, visceral relief. Like Kiefer, Kantor aspires to be the tragic, confessorial conscience of his country. *Getting Up* [Pl. 61] is an allegory of Russia's current attempt to get back on its feet. His pictures of patients in mental hospitals and of prisoners in Soviet concentration camps [*see* frontispiece] portray what Gorbachev might call the unacceptable face of Communism. They appeal in vividly emotional terms. Kantor resurrects with a vengeance the impulse that Russian painting has to campaign for a cause: his subjects might be straight out of Solzhenitsyn.

The ethical striving of Kantor's painting is emphasized by his preference for pictorial structures which echo the stark images of old Russian religious art. However, he paints not the ascetic physiognomy offered by the icons but the shaven-headed, emaciated look of suffering. Although this is a far cry from the heroic masks which stare out at us from socialist realist painting, Kantor's figures are of a type. As with socialist realism, this type has ethical purport. It is not the result of formal manipulation for its own sake. It appeals to our consciences, rousing pity rather than the

banal enthusiasm encouraged by socialist realism. It is interesting to trace the origins of Kantor's 'type of suffering' back to his early paintings: it might almost derive from portraits of members of his own family. One does not know whether Kantor himself has cause to feel insulted and injured. He is in any case an artist whose conception of painting reflects a deep awareness of the innate ethical striving of Russian art.

In contrast to the high tragic tone of Kantor's painting, its deliberate preoccupation with great themes, the work of Lev Tabenkin (born 1952) is concerned with the pathos of ordinary life. In his close-hued, tonal palette and reflective mood he owes not a little to the work of his painter father, Ilya. Lev Tabenkin paints the fragile, conditional nature of happiness and the human capacity for the tragic. His sombre paintings of people in the metro and on buses, middle-aged lovers and cripples, gypsies and refugees, reclaim art on behalf of the humble, exalting the obstinacy of their passions in an indifferent world [Pl. 58].

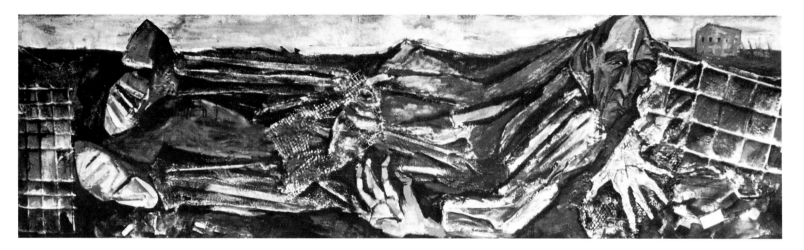

There is an absence of cant in Tabenkin's work which sets it apart from the socially engaged art of many of his contemporaries. His approving description of the peasant painter Pirosmani as 'simply a part of the world' indicates his aspiration towards an unsanctimonious art. Here he approaches Nesterova, although he would probably reject the theatrical setting of her dramas. Certainly there is a strand of his art which reaches beyond the social into a metaphorical mode of expression, most notably in his paintings of birds [Pl. 59]. These carry in essence the same emotional charge of joy, foreboding or despair as his paintings of people. They are metaphors for society and human relationships. Sometimes they offer a brooding, tragic prognosis. At other times, when the birds flock in easy formation through blue sky, we suspect that the goal of all the social striving of the Russian people is not materialist Utopia, but a spiritual regeneration, the attainment of a state of grace.

61. MAKSIM KANTOR.
Getting Up.
1987. Mixed media,
80 × 280 cm
(31½ × 110¼ in).
Studio Marconi, Milan

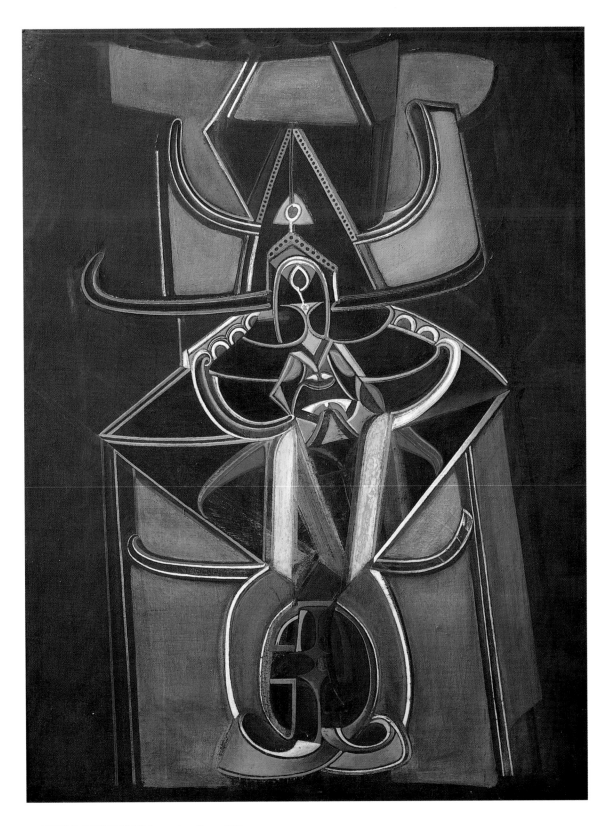

62. MIKHAIL SHVARTSMAN. *Incarnation of Space.* 1970.
Oil on board, 100 × 75 cm (39⅜ × 29½ in). The artist

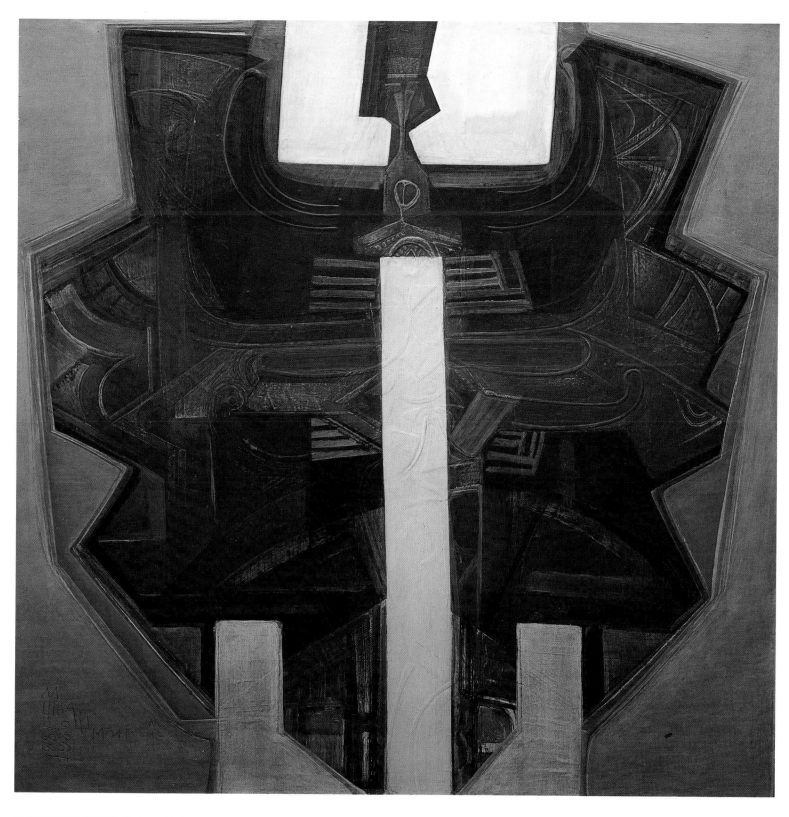

63. MIKHAIL SHVARTSMAN. *Space of the Trinity.* 1986.
Oil on board, 100 × 100 cm (39⅜ × 39⅜ in). The artist

OF GOD AND MAN

Russian artists' spiritual search

Social themes obsess many Russian artists. But a single range of aspirations could not fulfil them all. For art, given half a chance, engages each practitioner's sensibility in a unique way. There has long been resistance to excessively individual expression in Russian art. Icon painters were once warned by the Church authorities that 'whosoever paints an icon from his own imagination shall suffer eternal torment'. In the Soviet period, the institution of socialist realism and the academic training in art schools have been intended, in part, to impose conformity on art practice. Despite this, there are many artists in Russia who have rejected social themes and are concerned instead with the existential situation of the individual

The work of the late Ilya Tabenkin (1914–88), the father of Lev, might be said to have attained the furthest reaches of social art, where it ceases to be concerned with material existence and acknowledges an underlying spiritual quest. Tabenkin studied during the war at the Surikov Institute, while it was evacuated from Moscow to Samarkand. He was taught by the painter and writer, Igor Grabar (1871–1960). All that remained of that training echoed Grabar's insistence that pictures should be built around warm and cool contrasts; thus Tabenkin's close-hued harmonies are enriched by subtle oppositions of complementary colours. From a conventional education in academic painting and socialist realist ideology, over four decades he reached the position where communal, materialist values were not so much rejected as sublimated. It would seem he came to realize that, for Russians, social striving ultimately represents a desire for some sort of mystic communion.

The 'social' element in Tabenkin's work is refined to the point of dissolution. His paintings are always sparsely inhabited. Sometimes a human presence can only be surmised from a vague anthropomorphism in some figure: at other times there is no perceptible human presence at all. The possibility of a social relationship between Tabenkin's hieratic figures is suggested only by their presence together in a proscenium-like space [Pls. 64, 65]. But the nature of this relationship is most impenetrable. It is as if the figures are taking part in a ceremony, the meaning of which has been long forgotten. Ancient Church rituals echo within but are not the source of Tabenkin's world. These archaic figures suggest an idiosyncratic, not a specific form of religious feeling. Tabenkin invokes that moment, which Russian society struggles ceaselessly to bring about, when social relationships become entirely ritualized, when the individual becomes one with society but remains alone in himself. It is the moment when life attains the clarity of art, when absolute form becomes pure and transparent: the day the gods arrive.

Tabenkin's work has the quality of a summing-up, of arrival at some kind of personal spiritual reckoning. The idea that art can play a significant role in spiritual life is an ancient one in most societies; in Russia it is an idea which has proved more tenacious than elsewhere. Icon painting

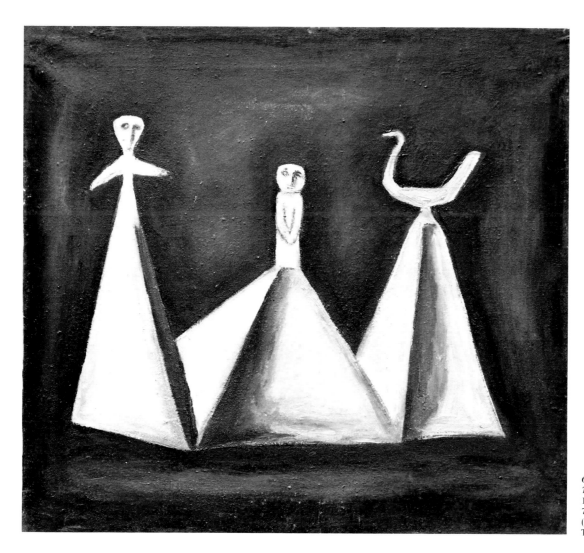

64. ILYA TABENKIN.
Triad.
1987. Oil on canvas,
70 × 80 cm
(27½ × 31½ in).
The artist

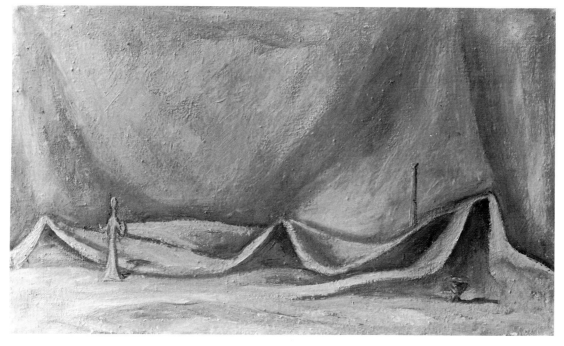

65. ILYA TABENKIN.
Composition.
1982. Oil on canvas,
47 × 81 cm
(18½ × 31⅞ in).
Private collection

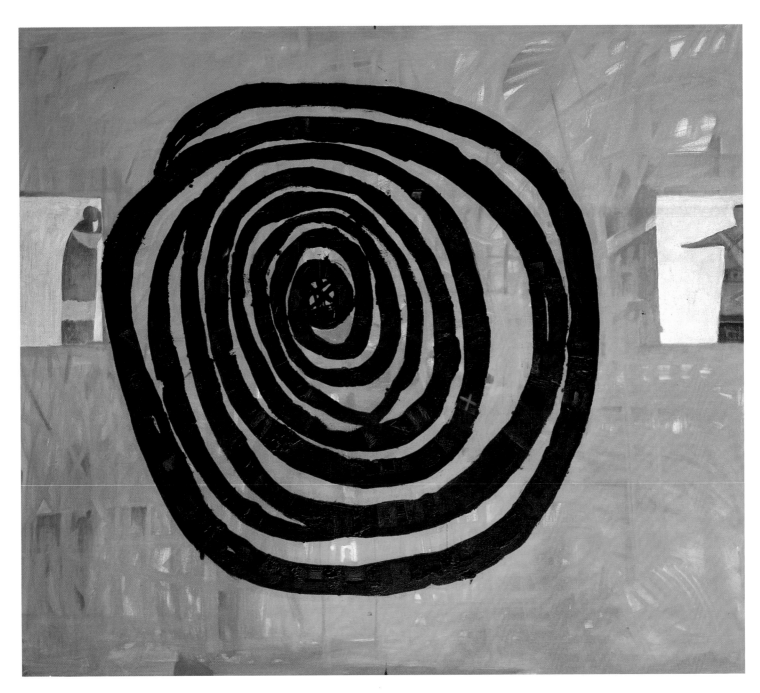

66. IGOR GANIKOVSKI. *Spiral.* 1987.
Oil on canvas, 140 × 160 cm (55⅛ × 63 in).
The artist

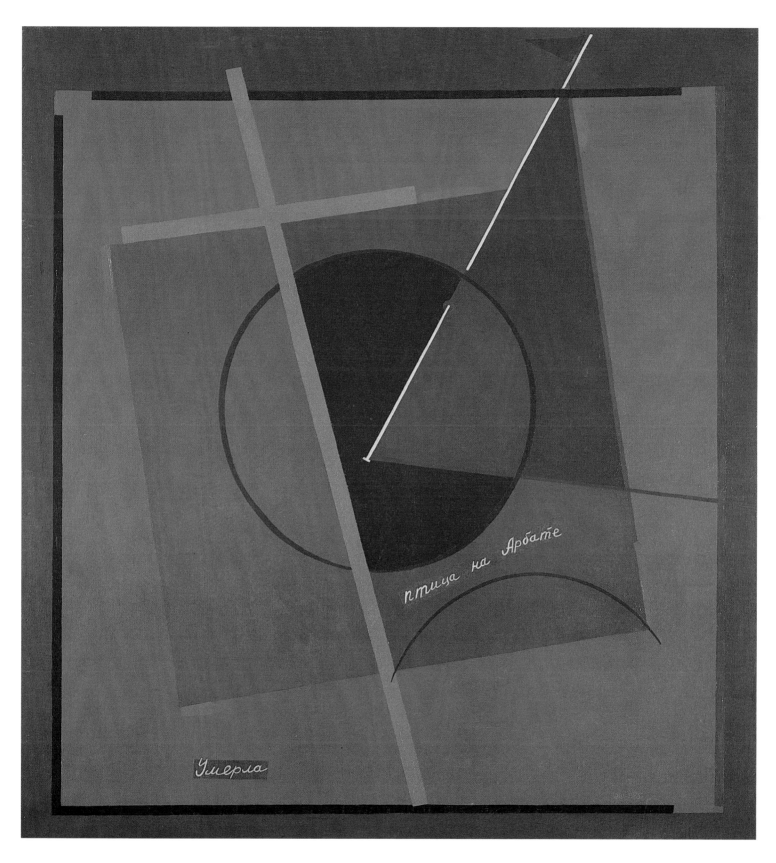

67. EDVARD SHTEINBERG. *In Memory of Veisberg.* 1985.
Oil on canvas, 90 × 110 cm (35⅜ × 43¼ in). The artist

'The bird in the Arbat . . . has died.'

remained the main form of artistic expression in Russia long after Renaissance humanism had swept the rest of Europe. To this day, icons of a traditional kind are still painted in Russia. Their cultural importance is implicitly acknowledged and signified by the authorities' refusal to grant export licences for them.

Mikhail Shvartsman (born 1926) is an artist who has responded profoundly to the icon painting tradition. He studied at the Stroganov Institute, Russia's leading school of monumental art, and subsequently worked for a time as an illustrator and monumental painter. Over the years, however, he has divested himself of the mundane sophistication of that background. Like the icon painters of old, he has come to accord a transcendental role to painting. He sees it as a means of communication with God.

Shvartsman has explored the same motifs in his paintings, which he calls 'hieratures', for many years (Pls. 62, 63]. His single-mindedness recalls the icon painter guided always by a template sanctified by usage. One of Shvartsman's motifs is that of a schematic human face. Another is a kind of abstract architectonics. These almost obsessive structures are built up over many years, acquiring a wrought surface, smooth and hard as enamel, which cries out to be touched: another echo of the icon's status, not just as image, but as holy object. The many-layered, symphonic texture of these paintings recalls Thomas Mann's description of music as 'complexity raised to the level of mystery'. The way back through the mesh of overlapping structures is the way to the mystery of God. The further you penetrate into the space of Shvartsman's paintings, the more nearly you approach Him.

Russian artists sometimes use the epithet 'genius' to describe Shvartsman. In the West, a genius is an artist who sums up a vast capability of artistic language: this characterizes our perception of Rubens or Turner or Picasso as geniuses. In Russia, genius can imply a converse achievement: the paring down of an artist's range in order for him to concentrate ever more closely on his essential spiritual mission. The archetype of such a conception of genius is the icon painter, the artist whose images provide access to God. In contemporary Russian art, Shvartsman is the painter who best corresponds to this conception.

Igor Ganikovski (born 1950) is a painter who, like Shvartsman, sees his role as being to provide images of a reality which transcends material existence. Some of his work owes something to Shvartsman in its exploitation of dense agglomerations of overlapping marks and forms. Ganikovski believes in life after death, in the continuity of the soul's existence. His paintings often attempt to provide a visual metaphor for this belief and its implications. He frequently resorts to elemental structures. His *Spiral* [Pl. 66], for example, suggests that all life is part of an unbroken, eternal continuum that emerges from the past and extends into the future. But despite the reassuring nature of this belief, Ganikovski's paintings often have a tragic aspect, presenting overcast and impenetrable surfaces. He is also indebted to the work of Pavel Filonov (1883–1941), an artist who pursued his vision through some of the darkest days of the Stalinist era, yet he sometimes seems to lack that artist's ineradicable optimism. Ganikovski's art espouses a fatalism which sometimes borders on despair.

Shvartsman and Ganikovski acknowledge God in their work, and conceive of their own situation in relation to Him. The metaphors of their painting are predicated on unambiguous religious belief. By contrast, an artist such as Vladimir Yankilevski (born 1938), though he also searches for images of spiritual truth, does so from a standpoint more humanist than religious. Yankilevski's career is in many ways a paradigm of that of the Russian non-conformist artist. He trained in the 1950s at the Polygraphic Institute under Eli Belyutin, the man who also ran the first unofficial art studio in Moscow's Arbat. He took part in the scandalous exhibition at the Manezh in 1962, and later shared a two-man show with its most notorious exhibitor, Ernst Neizvestny, whose slanging match with Khrushchev has become a legend.

Despite his involvement in the travails of unofficial art from its earliest days, Yankilevski has never addressed his work to the nature of Soviet power in the manner of near contemporaries such as Erik Bulatov. He has always taken a longer view, implying that political ideology is unimportant in contrast to the lasting significance of individual creative art; nevertheless, Soviet history has shown that there is a level on which such a belief in the inherent value of art has social obligations. For Yankilevski, the art of individuals can serve as the conscience of a society, whereas mass culture of the type promoted under Stalin or Hitler cannot. Art can help withstand the terrible threat to society when that which is desired masquerades as that which has been achieved; it can lay bare the lie on which Soviet culture subsisted for so long.

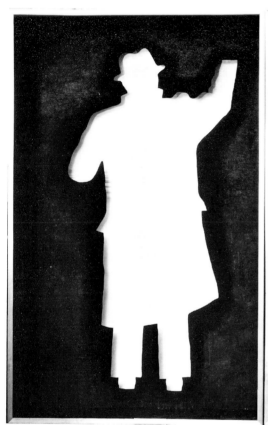

Yankilevski's favoured format is a large-scale triptych, sometimes extended to a pentaptych. While maintaining a remarkable stylistic unity in his work over many years, he has gradually extended the boundaries of his expressive means. The combination of painting and relief, already apparent in the 1960s, has in recent years sometimes developed into full-blown assemblage.

Yankilevski's intention is to present 'the simultaneity of various existential states in one work'. The *Triptych No. 14, Self-Portrait (In Memory of the Artist's Father)* [Pl. 68] is an example of his attempt to provide a transcendental view of human existence, one which places social and material reality in the context of eternal laws. The central panel is a literal, even banal, *mise-en-scène* from everyday life. A man travels on the metro; we do not see his face, which stresses the dehumanizing aspects of contemporary life, while his presence on the metro — a symbol of both social and mechanical engineering — indicates his alienation from nature. The two flanking panels of the triptych exploit the same form as the central panel (a man with his arm raised) but contrast apparent solidity with vacancy, for the now slightly plaintive figure is literally cut out of the surface of the painting,

68. **VLADIMIR YANKILEVSKI.**
Triptych No. 14, Self-Portrait (In Memory of the Artist's Father).
1986. Mixed media,
195 × 360 × 30 cm
(76¾ × 141¾ × 11¾ in).
The artist

69. EVGENI DYBSKI. From the series *Unchanging Subject*. 1988.
Oil on canvas, 130 × 195 cm (51⅛ × 76¾ in).
The artist

70. EVGENI DYBSKI. *Anxiety.* 1986.
Oil, tempera, relief paste on canvas, 150 × 200 cm (59 × 78¾ in).
The artist

enabling us to see through to an eternal, 'cosmic' landscape. These side panels give us, as it were, a view into the essence of man's existence, underlining his place in a cosmic continuum. The light and dark images refer respectively to the moment of his birth and his death, with the artist in transit between them. Thus the work evokes the memory of the artist's father, a man whose journey from birth to death has been completed.

While Yankilevski returns constantly to the human figure as a vehicle for his preoccupations, the painter Evgeni Dybski (born 1955) works through landscape as metaphor. His paintings derive from studies that he makes during regular trips to the Crimea. The works which are then developed in the studio exploit colour and texture in a way which Russian painters are often loath to do [Pls. 69, 70]. This links Dybski with an artist such as Chagall, who drew on the colourful tradition of Jewish folk-art.

His unabashed delight in aesthetic qualities does not diminish the emotional drama of his landscapes, drama which is often emphasized by the vulnerable, barely adumbrated human presences which inhabit them. Landscape in Russian art has traditionally functioned as a spiritual metaphor. This is apparent, for example, in Yankilevski's specialized use of landscape. During the Great Patriotic War, Russian artists painted idyllic landscapes to signify their faith in a blessed future. Dybski's painting has endowed landscape with a different, often unsettling significance which is peculiarly contemporary, creating an arena of emotion, sometimes of acute anxiety.

Dybski's aims are akin to those of Yankilevski. He is concerned to create images corresponding, through metaphors of form and colour, to his existential state. As with Yankilevski, and unlike Shvartsman or Ganikovski, his point of departure is not religious belief but a sense of his own being. None the less, like Yankilevski, he acknowledges a reality, a consciousness greater than his own: 'My fundamental task is the creation of my own world in the cosmos to which the Creator gave birth.' Ultimately, Dybski's goal is the creation of 'mystic form', that is to say paintings which, while explicitly a product of the artist's imagination, evoke a supreme power. The phrase 'mystic form' calls to mind icon painting, and in this respect Dybski's constant reworking of one motif – the Crimean landscape – echoes the icon painter's narrow range of subjects. His ability to associate this traditionally Russian quest for mystic communion with an awareness of the formal achievements of twentieth-century Western painting makes Dybski one of the most highly developed of young Russian artists.

The formal language used by the painter Edvard Shteinberg (born 1937) has, like Dybski's, an international flavour, but in his case its roots are indisputably Russian. Shteinberg does not conceal his debt to the constructivists and suprematists who flourished in the anarchic decade following the Russian Revolution. Shteinberg's father attended the *VKhuTeMas*, the progressive art school of the 1920s, and he himself first saw the work of the Russian avant-garde at the Moscow home of the Greek collector, George Costakis, in the early 1960s. He has paid explicit homage to Malevich in more than one painting.

Shteinberg's work emphasizes how the Russian perception of the post-Revolutionary avant-garde differs from the Western view. Where Western artists tend to value the work of this time primarily for its qualities of formal innovation, Russian artists see above all familiar metaphors, albeit in new clothes. For Shteinberg, Malevich's *Black Square* [*see* Pl. 11] is not significant for the amount of pictorial space it squeezed out of the canvas, but as the calculated antithesis of icon painting, the 'objectified absence of God'.

Shteinberg requires his geometry to carry an equally portentous charge. Like Yankilevski, his constant theme is humankind's relationship to the cosmos and its immutable laws. For Shteinberg, abstract elements derived from suprematism have a metaphorical significance: 'I have deciphered Malevich, and I believe I have not erred. The rectangle, that is death, loss, a yearning for God.' In

his lyrical geometric landscapes of the 1970s, compositions were built about a horizon line, where heaven and earth meet. Around 1980, the landscape format gave way to that of a window, and then in 1985 Shteinberg began a series of emphatically earth-bound pictures, devoted to life and death in the village of Pogorelka.

This *Village Cycle* heralded a period in which, under the strain of having to come to terms with tragic events in which personal and sentimental considerations were pre-eminent, Shteinberg's commitment to a pure pictorial language was shattered. Words, and sometimes clearly figurative imagery, became necessary components of his painting. The fragments of text in *In Memory of Veisberg* [Pl. 67] refer to the death of Shteinberg's old friend, the painter Vladimir Veisberg: 'The bird in the Arbat . . . has died.' In this rethinking of the tenets of his art, Shteinberg echoed Malevich's own rejection of non-objective art: abstraction had become an inadequate vehicle for the multiplicity of his experiences.

More recently, Shteinberg's tragic mood has lifted and he has returned to the unadulterated geometric language he previously used. His work as a whole makes it clear how central for a Russian artist are the great issues of existence – life and death, one's relationship to God and the cosmos – and he has shown how this concern can charge even the most abstract pictorial elements with spiritual meaning.

THE WAY WITH WORDS

Text and image

It is not uncommon to hear Russian artists expound the belief that the greatest achievements of Russian culture consist neither in painting or sculpture, nor even in music or ballet, but in literature. In saying this, they are not depreciating their own activity, but simply recognizing a bias towards verbal expression in the culture as a whole. Even in the visual arts there is a liking for 'literary' painting – painting which tells a story, or even, in the case of history painting, draws on literary sources.

It is perhaps not surprising therefore that one of the most striking of Russian art forms in the Soviet period should be poster design, which exploits combinations of image and text. Posters for spreading propaganda are ubiquitous: it is inconceivable that a Russian could grow up without their becoming an integral part of his consciousness. Many artists regard the poster as a debasement of painting and drawing which spoils the eye for the real thing. But more memorable than the figurative images are the slogans, each one a permutation from a narrow repertoire of stock phrases. The lexicon of Communist propaganda is minuscule, which is perhaps the secret of its stultifying effect.

Verbal propaganda, of which poster art is only one manifestation, suffuses everyday life in the Soviet Union. Yet these doctrinal messages and exhortations are abhorrent to many Russians. They sense – and resent – that their patterns of thought are coloured by indoctrination. So far as art criticism is concerned, discursive thought often seems to be replaced by the ritual incantation of established attitudes. Not a few artists see their role as being to analyse, resist and debunk propaganda and the unreal atmosphere it creates in everyday life. These artists often deliberately employ the same mechanism of image-text combinations that, in the context of everyday life, they wish to resist or unmask.

The work of Ilya Kabakov (born 1933) is too diverse to explore fully in this book. Since his association with Belyutin in the early 1960s, he has been extemely influential in the unofficial art movement. He is not interested by aesthetic questions, problems of composition or *belle peinture*; far from it – on occasion his painting technique deliberately parodies the leaden paint-handling displayed by much socialist realism. Kabakov's *modus operandi* often suggests the dramatist as much as the traditional painter. He has created many illustrated albums [*see* Pl. 18], which narrate in words and pictures the fortunes of an innocent abroad. The albums are viewed in a quasi-theatrical way, as it is the artist himself who turns the pages for the viewer.

His *œuvre* can be seen as a series of utterances informed by dramatic irony. Kabakov directs our attention to the gap which often exists between apparent meaning and the reality which lies mute, unexpressed, concealed behind it. His work is an analysis not of the surface of existence, the anecdotal reality of successive Soviet leaders and national events, but of an underlying conflict: 'I see this fundamental conflict – of speech devoid of meaning and of meaning not given form by

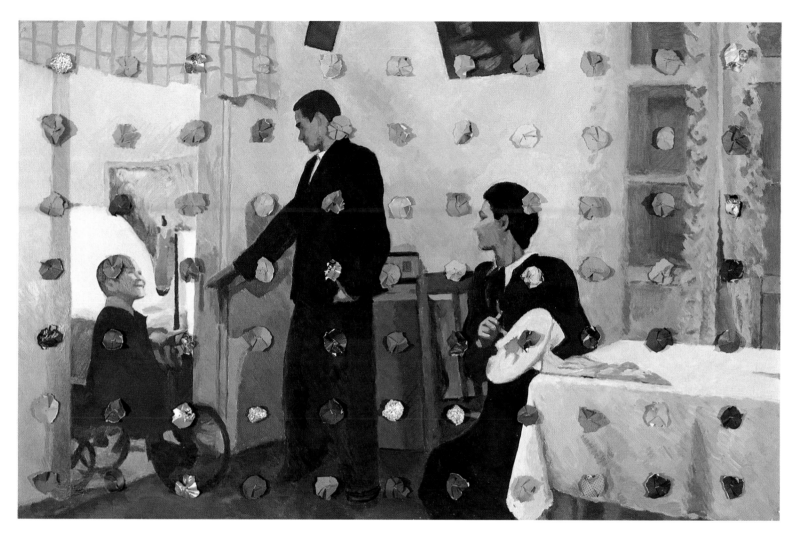

71. ILYA KABAKOV. *Prazdnik.* 1987.
Oil and rosettes on canvas, 100 × 150 cm (39⅜ × 59 in).
Galerie de France, Paris

72. ILYA KABAKOV.
Whose is this Grater?
1987. Mixed media,
70 × 120 cm (27½ × 47¼ in).
Galerie de France, Paris

Anna Petrovna Savchenko:
'Whose is this grater?'
Nikolai Lvovich Kruglenko:
'Dunno.'

73. ANDREI ROITER.
One Cup of Tea. 1987.
Mixed media, 110 × 150 cm
(43½ × 59 in). The artist

speech – in everything which surrounds me, and above all in myself.' Kabakov's own words are striking.

One of Kabakov's most characteristic devices is the use of verbal narratives in, or sometimes almost as, paintings. *Whose is this Grater?* [Pl. 72] is a fleeting drama played out in one of Kabakov's favoured locales, a communal apartment. Communal apartments, some housing several families, still exist in Moscow and are common in Leningrad. The painting is one of ten which have the same format and are intended to be exhibited all together. Like the other paintings, it retails a brief conversation which takes place in a kitchen. Anna Savchenko needs to use a grater; she sees one, and since all graters are much alike, asks her co-tenant, Nikolai Kruglenko, a member of another family, to whom it belongs. He replies: 'Dunno.' The implication is, of course, that he is prevaricating: he perhaps knows whose grater it is, yet in the strained atmosphere of a shared kitchen he is being deliberately unhelpful.

The characters are made-up, but the oppressive dark blue of the wall on which the grater hangs has the smack of remembered authenticity. When all the paintings in the series are hung cheek-by-jowl, the colour gives them the aspect of a malevolent ocean, spewing up isolated phrases like driftwood. We are looking at a world where, by dint of long enforced cohabitation, social ritual has been distilled to an extreme reduction. A real exchange of conversation never takes place; banal, practical questions are ventured and answered in kind, that is all; and behind this impenetrable, gloomy façade, we wonder, do real hearts beat and passions rise?

The *Kitchen Series* illustrates the communal character of Russian life, which has roots stretching back long before the advent of Soviet power. By no means all Kabakov's work incorporates texts. His series of *Prazdniki* – the word means 'celebrations' or 'holidays', and refers both to private events such as birthdays, and to public holidays instituted by the State – focuses more closely on the institutional flavour of life under Soviet power, and has no textual element. These paintings examine the way in which values and feelings that ought to be the object of individual conscience have been made the subject of empty ritual. Kabakov himself has related, with characteristic irony, how, having painted a scene of celebration [Pl. 71], he found it did not induce in him a corresponding feeling of happiness, and so he tried to improve things by tarting the picture up with paper flowers. Kabakov's cynicism about State power, his struggle to maintain his dignity in the face of its relentless ideological pressure, fixes him in the long tradition of Russian artists who have constituted a kind of permanent opposition to the contemporaneous political regime.

In a comparable vein, Dmitri Prigov (born 1940) makes a target of the grand propaganda exercises of the Soviet State. His series of *Banki*, or *Tins* parodies the got-up petitions with which the State has tried to outface the world at large [Pl. 74]. Prigov substitutes a throwaway tin for grand ceremonial displays; the petitioners' signatures are drawn from a few scattered acquaintances. Anyone may call for 'THE COMPLETE AND UNCONDITIONAL DISARMAMENT OF AMERICA', and surely it is the duty of every patriotic Soviet citizen to do so! Appealing for it may not bring it about, but at least Prigov has done his ironical best to demonstrate that his heart is in the right place.

Prigov is primarily a poet, one of an important group of writers known loosely as Conceptualists, which includes Vsevolod Nekrasov, Lev Rubinstein and Vladimir Sorokin. Perseus-like they attempt to rise above the relentless stereotypes of Communist evangelism by reflecting them and rendering them powerless. Nevertheless, despite the high ethical tone of Prigov's subversive programme, he manages to display in his *Bestiary* – a series of heraldic portraits of leading public figures – a lurid poetaster's delight in the grotesque [Pl. 76]. But then public life, with its secret self-serving rituals, is perhaps innately grotesque.

The self-appointed task of mature artists such as Kabakov and Prigov is effectively to liberate and heal a consciousness damaged by long incarceration. There is a high moral seriousness about

74. DMITRI PRIGOV. *Signature-Tin.* 1977–8.
Mixed media, 25 × 10 × 10 cm (9⅞ × 4 × 4 in).

'A tin of signatures for the complete and unconditional disarmament of
America.'

75. YURI ALBERT.
Art for Sailors. 1987.
Oil, enamel on hardboard,
320 × 100 cm (126 × 39⅜ in).
The artist

76. DMITRI PRIGOV.
Gorbachev, from the series
Bestiary.
1987. Ink on paper,
31 × 21 cm
(12¼ × 8¼ in).
Madison Museum,
Wisconsin

such a goal which often seems to be absent in the work of those younger artists whose work, in the manner of Kabakov, exploits conjunctions of image and text. Georgi Kizevalter (born 1955), for example, calls himself a 'disciple of Kabakov', and this is reflected in his paintings, where texts often play an important role, and in his penchant for making books. His work, which concentrates more on artistic and sexual mores than political ideology, has a light-hearted satirical air that is rather different from the sardonic undertones of Kabakov. Kizevalter's work often explores eroticism and sex, areas which even today Russian artists conventionally steer clear of.

Kizevalter's activity, though centred on painting, is diffuse. Kinetic objects, performance work as a member of the performance group Collective Actions, photography, journalism, all occupy his time. He makes a virtue of the small harvest and marginalized nature of his activity in all these areas. His attitude to art, like his attitude to life, is the ironic stance of an intellectual actor searching for a role in a better production. His most successful book-work is a satire on the cosy world of unofficial artists, which he characterizes as a mutual admiration society where every effusion is hailed as a work of genius. *A Blind Man Asks a Parrot for Alms* [Pl. 77] also parodies the nature of artistic debate. Around the central allegory, which expresses, one surmises, the relationship of art lover to art critic, men in suits express thoughts about art, ranging from the hopelessly conservative 'And where is our national school?' to the trendy 'Here the decadence of post-modernism is clearly visible.'

Like Kizevalter, Yuri Albert (born 1959) has also satirized the art world. Many of his early pieces were simple texts, sometimes presented on scruffy pieces of hardboard without that pretension to the status of a desirable object which characterizes much Western conceptual art. One work, which probably has a small niche in Soviet art history as the first piece of conceptual art exhibited at an official exhibition, stated simply: 'A crisis has occurred in my work, I am confused, embarrassed, and don't know what to do now.' It is perhaps a tribute to the ingenuousness of the Moscow public, or its good sense – two things which, as far as art appreciation is concerned, are often one and the same – that they scrawled various helpful suggestions on the wall in reply.

It is a pointer to the new consciousness of young Russian artists (when compared to their elders) that, rather than being determined by social pressures, much of Albert's activity seems inspired by a personal crisis of belief: is he or is he not an artist? At one time this activity took the form of exhibited statements in which he tried to establish his irreducible artistic self by a process of elimination, beginning with *I am not Kabakov* and continuing with the exclusion of other major artistic figures. Having thus fully explored the concept of himself as an artistic nullity, he has in the course of time been obliged to accept himself as an artist, if only because he is transparently not a factory worker, not a Party activist, not a black-market trader, etc. At this point, the question of his medium comes to the fore. If he is, ineluctably, an artist, then what is the nature of his language? In a way which is consistent with his past activity, which can be summed up as 'I do not find, I seek', Albert has embarked on a series of paintings exploring various alternative 'alphabets' or language-forms, from the shorthand of the stenographer to braille and the flag signals used by sailors. While he regards these works as democratic, communicating with people who are often bemused by high art, one implication of these sorties into the communication-world of other specialist groups is that art is essentially a language for initiates, inaccessible to Ivan Average: a conclusion unpalatable to those Marxist-Leninist aestheticians who are worried by the burgeoning of new art forms in Russia.

On another level, a painting like *Art for Sailors* [Pl. 75] tries to develop the tradition of image-text combinations in a way which is typical of a number of young artists. It attempts to close the gap between image and text and make the painting into a more convincing aesthetic product than is often the case with, say, Kabakov's pragmatic compositions. This attempt is exemplified in the work of the Lvov-based artist, Svetlana Kopystyanskaya (born 1950), who works as a book-illustrator and painter. Her word-covered landscapes try to do justice to the simple beauty of the countryside [Pl.

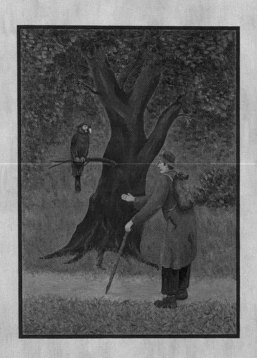

78. SVETLANA KOPYSTYANSKAYA. *Landscape.* 1988.
Tempera and handwritten text on canvas, 125 × 160 cm (49¼ × 63 in).
Private collection

77. GEORGI KIZEVALTER. *A Blind Man Asks a Parrot for Alms.* 1988.
Oil on canvas, 140 × 110 cm (55⅛ × 43¼ in). The artist

'And where is our national school?'
'I don't understand what the author wanted to say.'
'The subject is out of date, and anyway, it's not painting.'
'Here the decadence of post-modernism is clearly visible.'

79. VADIM ZAKHAROV.
AS-8. 1987.
Ceramic tiles, cement
and hardboard, each panel
200 × 60 cm
(78¾ × 23⅝ in).
The artist

78]. Her *Dialogues* and *Conversations*, in which passages of text, straining to communicate, appear and disappear across a surface of buckled canvas, have a convincing presence simply as objects.

Albert's language-paintings, while ultimately indebted to Kabakov, represent a departure from the overt engagement with ideology, which so often characterizes the textual pieces of older generations. He favours a more ironic approach. This change of perspective across the generations is also apparent in the work of Andrei Roiter (born 1960), who began his exhibiting career at the Malaya Gruzinskaya Street Gallery at the age of seventeen. He displays a positively light-hearted attitude to a tradition resigned to bearing such a heavy ideological burden. In his paintings, words are often replaced by fragments of words, an echo of the way in which the Soviet bureaucracy loves to fabricate ludicrously extended compound nouns (in the same way as Orwell's 'Nu-speak') from truncated parts: the longest of these concoctions, dreamed up in the 1950s, was over sixty letters long. Roiter's work enters into the spirit of this fantastical world of instant concepts, conjoining

lexical fragments with banal imagery to make 'phrases' which are like equations for a purely speculative mode of existence [Pl. 73]. In the sense that Roiter's paintings suggest the feasibility of a novel and undreamt-of world, they are a distant echo of the mad Utopianism of the Stalinist era. Nowadays, he seems to be saying, you can see the funny side of it.

It is clear from the work of artists such as Kizevalter, Albert and Roiter that the younger generation of artists not born into the Stalinist era have made of the Kabakovian inheritance something relatively light-hearted. They may find the conditions of life absurd, but not apparently threatening. Their work lacks Kabakov's cutting edge. By comparison with the creative and intellectual range of artists such as Kabakov and Prigov, their work has a narrow constituency.

Of all the artists of the younger generation, it is Vadim Zakharov (born 1959) who offers the most authentic development of the philosophizing, absurdist, socially engaged theatre of Kabakov. Zakharov describes his activity as a 'Functioning in Culture'. This activity includes participation in performances, sculpture and painting. He views each work as the expression of a unified ideology. He creates works in series, normally of eight works each, and works from one series are often used as a source of inspiration for other series. The result is an art practice which he has characterized as a 'self-organizing system'. To underline this sense of system, he usually gives his works inscrutable serial numbers for titles.

Zakharov's work is diverse, but always witty. Even his non-figurative paintings are not without a streak of humour. *AS-8* [Pl. 79] narrates, as it were, the adventures of a small excised shape, a piece of damage which the artist seems to cherish. One of a number of related paintings, it evokes, with a certain systemic fatalism, organic processes of growth and decay which seem akin to Zakharov's notion of the art-making process itself. In some of his explicitly figurative paintings, elements of statuary and baroque decoration are depicted coming to life and uttering opaque, provocative phrases. He shakes an antique culture into impertinent life [Pl. 80]. In their enigmatic quality these latter paintings owe something to the oracular art of Kabakov.

The ambitious range of Zakharov's activity is made convincing by his resolve to maintain it as an organic whole. Because each work is conceived of in relation to others, a kind of family relationship, however distant, exists between them all; between, for example, *AS-8* and *Barokko*. His work attempts to acknowledge the imponderables and contradictions of life which are normally so resistant to art.

80. VADIM ZAKHAROV.
Barokko (part of tetraptych).
1986. Oil on canvas,
150 × 200 cm (59 × 78¾ in).
Galerie de France, Paris

'Good Lord! If you hear a madman's cry, don't take any notice. It's the cry of a love gone stale, planting a kiss on the top of my head. You see, I'm a dwarf, perishing at my own little hands.'

82. OLEG VASILEV. *Slanting Beams.* 1984–7.
Oil on canvas, 123 × 123 cm (48⅜ × 48⅜ in).
Phyllis Kind Gallery, New York

81. ERIK BULATOV. *Ne Prislonyatsya.* 1987.
Oil on canvas, 240 × 170 cm (94½ × 66⅞ in).
Kunstmuseum, Basel

I LIVE AND I SEE

Art and ideology

Whatever the future may hold, Russian artists have grown up in a world where there are no neutral themes and no neutral styles: they are all in theory susceptible to evaluation according to a scale of ideological value. Such a scale has never been developed in detail (and never could be), but the rough adumbration of one exists and is applied in the mind of every citizen. For an artist this has had the admirable consequence that he can expect roughly the same judgement of his work from a plumber, a Party activist or a professional critic. The critic (and perhaps the same is true in the West) is distinguished only by his repertoire of high-falutin phrases.

This democratic state of affairs, as it affects art criticism, is changing as the official art world admits the validity of styles and subjects previously held to be beyond the pale. These require their expert interpreters. But the underlying cause of this critical unity – the thoroughgoing ideologization of everyday life – continues to provide a subject for many artists. They strive to liberate their own thinking by confronting and understanding the mechanism which arbitrates it. Whereas Kabakov and Prigov frequently attempt this by using textual components in a work, other artists deal more with the accoutrements of Soviet culture, the architecture and statuary, the ceremonial uniforms and public symbols of nationhood. To these must be added the ubiquitous slogans which have acquired an iconic status as signs grasped visually, without the effort of reading.

Erik Bulatov (born 1933), like his exact contemporary Kabakov, is one of the most influential members of the unofficial art movement. An accomplished student, one of his early paintings of a traditional kind was chosen for the Soviet pavilion at the 1957 International Youth Festival in Moscow. However, a growing sense that his education, for all its rigorousness, had not been all that he needed, caused Bulatov to rethink the tenets of his art under the particular influence of the graphic artist and painter, Vladimir Favorski (1886–1964), a teacher of considerable significance for many non-conformist artists in the late 1950s and early 1960s.

Bulatov's work is best understood through an analysis of his conception of space. He characterizes the space of the real world, inhabited by the viewer of a painting and pervaded by ideology, as 'social space' [Pl. 83]. The surface of a painting divides this social space from the space of the painting, a space existing, as it were, on the other side of the canvas. For Bulatov, this deep illusionistic space is frequently more enticing than the social space suffused and defined by Communist ideology. And because this ideology is distorting, the space of the painting is to be considered more true than the social space.

The slogans which Bulatov often paints across the surface of his paintings relate to the social space inhabited by the viewer. In a seminal work of the 1970s, Bulatov wrote the slogan *SLAVA KPSS* (i.e. GLORY TO THE COMMUNIST PARTY OF THE SOVIET UNION) across a blue sky flecked with clouds. The slogan, painted in dazzling Communist scarlet, seemed by virtue of the

violent contrast of colours to detach itself from the painting and invade the real space of the gallery – that is, to occupy the social space, its proper domain.

The painting *Ne Prislonyatsya* [Pl. 81] is more ambiguous. The slogan is one written across the windows of Russian trains, warning passengers not to lean against them. Thus on one level, the painting represents a familiar scene: in the background, the countryside, in the foreground, written as it were on glass, a familiar injunction. In this sense, the slogan reminds the Russian viewer of myriad other interdicts which permeate his life: prohibition would sometimes appear to be the mainspring of the Soviet system. From another point of view, however, the painting is making an almost ecological plea not to interfere with nature. More profoundly, one is being admonished to leave the sacred Russian countryside, soul of Mother Russia, alone. Thus the slogan has equivocal status, part social and part transcendental, and is correspondingly painted white, uniting it with the white wall on which the painting hangs and causing it to hover between the social and pictorial spaces.

While Bulatov's perceptions about Russian life under the Soviet ethic have broad currency among the intelligentsia, his manner of articulating the contrasting deep spaces of society (in front of the canvas), and the liberating imagination (through the canvas), by purely pictorial means, such as colour contrast, is genuinely idiosyncratic. The idea that salvation lies ultimately in the illusory depth of the painting is a dim echo of the concept of an icon as a means of access to God. Perhaps the only other artist to explore similar ideas about the factitious nature of the social world and its relationship to the 'real' world of painting is Oleg Vasilev (born 1931), who has worked side-by-side with Bulatov for many years. They studied together in the 1950s, together illustrated children's books, and occupy adjacent studios in a splendid Stalinist apartment block.

84. OLEG VASILEV.
Conductor of Birds.
1988. Oil on canvas,
180 × 130 cm
(70⅞ × 51⅛ in).
Studio Marconi, Milan

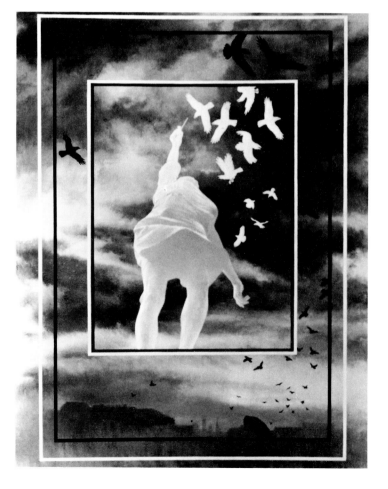

83. ERIK BULATOV. *Perestroika.* 1988.
Oil on canvas, 200 × 200 cm (78¾ × 78¾ in).
The artist

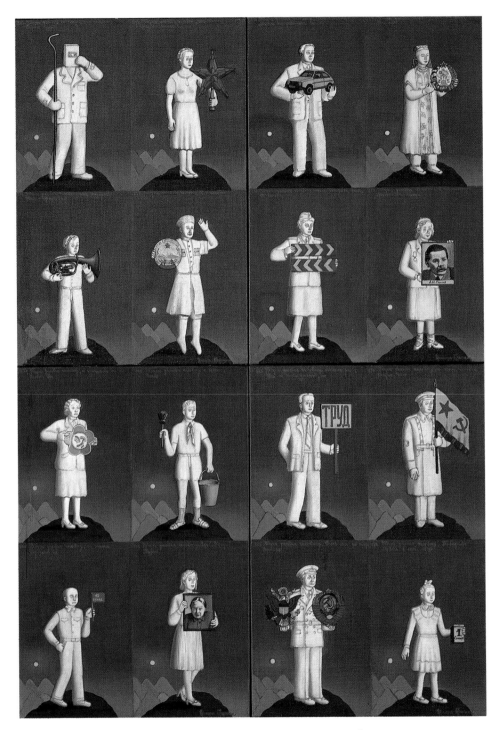

85. GRIGORI BRUSKIN. *Fundamental Lexicon* (fragment). 1987.
Oil on canvas, each panel 55 × 38 cm (21⅝ × 15 in).
Private collection, West Germany

86. GRIGORI BRUSKIN. *Alefbet* (left-hand panel of diptych). 1988.
Oil on canvas, 116 × 88 cm (45⅝ × 34⅝ in).
Galerie Nannen, Emden, West Germany

Vasilev's work ranges wider than Bulatov's. It encompasses paintings dealing expressly with the nature of Soviet art and society, as well as portraits and landscapes of a deceptively straightforward kind. *Slanting Beams* [Pl. 82], on which he worked for many years, is a painting of his wife in a cornfield. The beam of sunlight which illuminates her has metaphysical significance for Vasilev: it is the light of memory, the light which suffuses the images of the world that we conjure up in our minds. For Vasilev, this world of memory is the most convincing world there is. 'That which surrounds me, the visible and tangible world, appears to me more as something remembered than actually existing. It is no more real for me than the images of childhood, fading away remotely, on the edge of my field of vision, inaccessible to a direct gaze.'

For a Westerner, a puzzling aspect of *Slanting Beams*, coming as it does from a non-conformist artist, is its similarity at first sight to the more dream-like creations of the Stalinist period, such as Arkadi Plastov's *Haymaking* (1947) [*see* Pl. 20]. On a mundane level, Vasilev certainly has a common interest with some Stalinist painters in impressionist technique; in Vasilev's case, in divisionism. But there is also in his work an echo of the other-worldly atmosphere which Stalinist painting sometimes generated. This short-circuiting of our conventional way of categorizing Russian art suggests an underlying unity in the striving of some Russian artists which transcends more obvious conflicts.

Vasilev's socially oriented work also often has an autobiographical flavour. The painting *Conductor of Birds* [Pl. 84] is bathed in his characteristic bright light of memory. Above a view of Moscow painted from his studio window, Vasilev has painted himself in the pose of a statue which once stood on top of a building in Gorky Street, Moscow's main thoroughfare. This statue of a woman featured in one of the views of Moscow which Vasilev was preparing in 1958 for his graduation show at the Surikov Institute. Between Vasilev's illustrating the statue and the time of his diploma exhibition, the statue itself was taken down by the authorities for alleged indecency: people were gawping up its concrete skirt. Vasilev, unaware of this decision to safeguard public morals, duly presented in his show the work depicting the statue, for which he was absurdly taken to task. A wry painting, reminiscing at a distance of thirty years, *Conductor of Birds* underlines the way in which for Vasilev, as for Bulatov, the ideologized world of everyday life has to be grappled with and transmuted by the creative power of the imagination.

Vasilev's ill-fated lady was just one of the statues which peppered Russia in the 1950s, expressing the ideals of Soviet health and beauty, moral accomplishment and social aspiration. They were a feature of the childhood of Grigori Bruskin (born 1945). Their role, which was to embody in the vernacular of academic form an all-embracing ethical system, continues to fascinate him today. His *Fundamental Lexicon* [Pl. 85] is an infinitely extensible series of paintings inhabited by figures which seem, like cheap Soviet statuary, to be cast in plaster. They add up to a petrified gallery of the types of everyday life. Each figure carries an object, effectively an attribute of some kind, and is accompanied by a brief text. The texts all begin portentously: 'Life is given to man . . .' and continue with a brief, inconclusive phrase to the effect of how, or why, life is so given. The relationship between these three elements (the figure, the attribute and the caption) is not specified, but rather open to interpretation. Whatever sum total of meaning a viewer may extract from an image, each one exploits a central feature of Communist culture – the way in which everything, even the most trivial action or object, is susceptible to ideological judgement and can have an ethical significance apportioned to it. We are forced to search for and impose a meaning even when the combinations of figure, attribute and caption are apparently senseless. The whole amounts to a *reductio ad absurdum* of the submission to ideology in Soviet art and life.

The *Fundamental Lexicon*, structurally evocative of an iconostasis, is a kind of contemporary typology. The shaping undercurrent of religious concepts is basic to Bruskin's ideas. It reflects his analysis of Communism as a credo dominated by patterns of thought derived from religion. He

points, for example, to the way in which the writings of Lenin have been enshrined as a holy text, the fount of wisdom, the correct interpretation of which engages the high priests of Communism, the Party élite, in perpetual debate.

Fired by the comprehensive nature of the Soviet system of values, Bruskin has produced the *Alefbet*, an ambitious attempt to create for Jewish culture an analogous symbolic resource in the visual arts [Pl. 86]. The structure of the *Alefbet* series is the same as that of the *Fundamental Lexicon*: each image consists of figure, object, text. But the intention in the *Alefbet* is less ironic: it is intended as a constructive rather than an analytical gesture. Bruskin's aspirations seem doomed to disappointment. An approach to art which, in the *Fundamental Lexicon*, exploits the received forms of a powerful existing culture, is powerless to revive and sustain another, ailing one. The *Fundamental Lexicon* is intelligible where the *Alefbet* is obscure; the former is contemporary, the latter archaic. Jewish culture, if it is to establish itself (in the face of age-old anti-Semitism) as a self-sufficient, discrete entity in Russia, will have to do so first on a more fundamental level than that of Bruskin's intellectual commentaries.

Bruskin's fascination with the petrified forest of Soviet culture is echoed by Boris Orlov (born 1941), a sculptor who makes us aware of the highly formalized nature of that culture's visual rhetoric. One major strand in his work is a series of wooden busts with chests grossly enlarged to accommodate decorations, slogans and other tokens of State ceremonial. The ceremonial wings, each dedicated to a Communist virtue and stacked together in *Bouquet of Wings* [Pl. 88], are a kind of triumphant nosegay, assembled in an urn for easy delectation. This casual, decorative conglomeration of the purely symbolic has a rough-hewn construction which echoes the coloured, carved-wood sculpture of the Russian folk-art tradition. It is the sculptor's profession of simple, traditional values despite the trappings of pomp and circumstance.

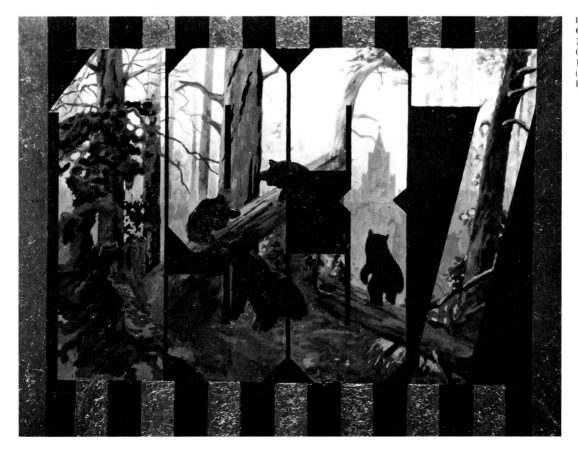

87. NIKOLAI OVCHINNIKOV.
The Year 1937. 1987.
Oil on canvas,
150 × 200 cm
(59 × 78¾ in).
Private collection

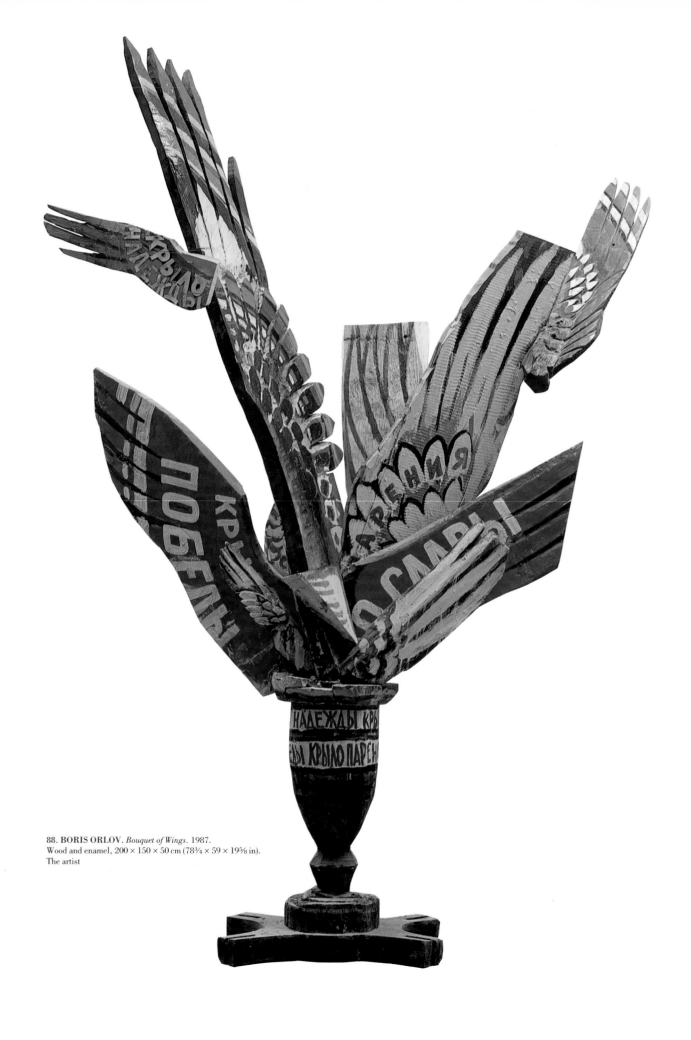

88. BORIS ORLOV. *Bouquet of Wings*. 1987.
Wood and enamel, 200 × 150 × 50 cm (78¾ × 59 × 19⅝ in).
The artist

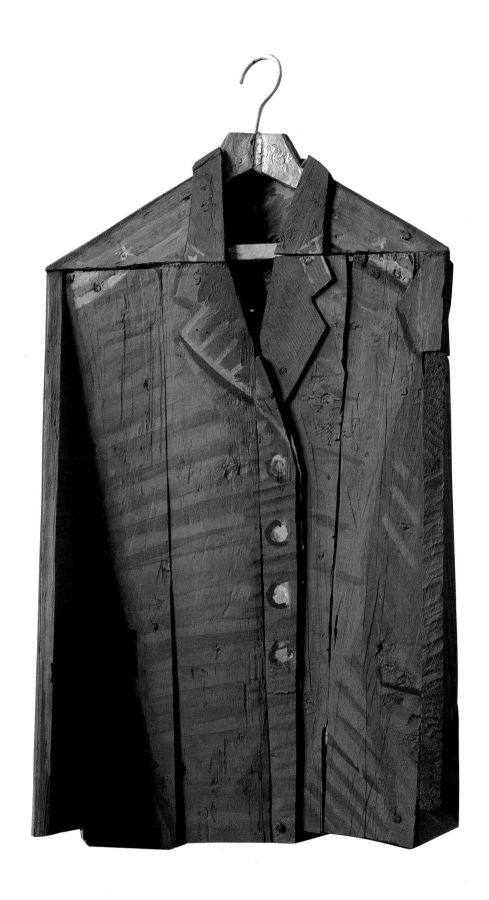

89. DMITRI TSYKALOV. *Major's Jacket.* 1986.
Wood and tempera, 97 × 47 × 18 cm (38¼ × 18½ × 7⅛ in). Studio Marconi, Milan

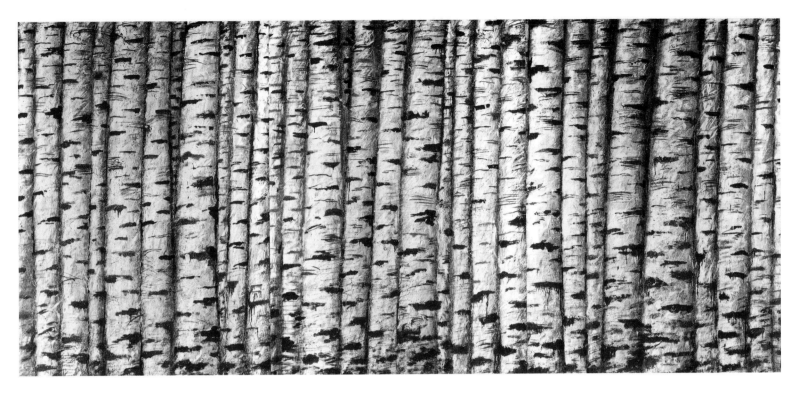

90. NIKOLAI
OVCHINNIKOV.
Birch Trees.
1987. Oil on canvas,
200 × 450 cm
(78¾ × 177⅛ in).
Galerie de France, Paris

This folk-art tradition is also exploited by Dmitri Tsykalov (born 1963). His series of painted wooden jackets (1986–7) suggests the multiplicity of social roles which can, like a jacket, be taken off and put on in Soviet society [Pl. 89]. Unlike Bruskin, whose *Fundamental Lexicon* gives no hint of a life independent of social and ideological roles, Tsykalov leaves us with the impression that there exists behind the public face a core of unconditioned humanity.

The intense focus of these artists on the nature of life and thought in Soviet Russia gives their work a peculiar flavour of self-absorption, unaffected by cultural debate beyond the confines of the Communist State. This self-absorption is often characterized in the West as something enforced by a totalitarian government on a helpless people. That it has a more complex origin is recognized by the painter Nikolai Ovchinnikov (born 1958). The folk-tale tableau of his painting *The Year 1937* [Pl. 87] offers a mordant allegory of State terror. His work often uses images of birch trees, a tree that is to Russia as the oak is to England or the maple to Canada: a symbol of the nation. Ovchinnikov's vast painting *Birch Trees* [Pl. 90] presents a solid, unbroken wall of these trees. It is not enough to say that, in crude terms, he portrays his country as an immense prison, or alternatively as a land impenetrable to outsiders, depending on which side of the birch trees you consider it to lie. For Ovchinnikov, this age-old isolation is something essentially Russian, pathological, inflicted by the Russian soul and endemic to the Russian soil.

THE VIEW FROM KAMENNY MOST *

Russian artists and international culture

Although many Russian artists are engrossed in concerns relevant only to the Soviet State, they are aware of their cultural proximity to the West. During the *zhdanovshchina*, which continued after Stalin's death, it was a risky business for an artist to make too open a demonstration of this awareness. However, with the rejection of Stalinism, Western culture, along with the sense of shared international values, has come to have an increasing influence on Russian artists.

In the 1950s there were one or two exhibitions of Picasso and Léger, artists who had Communist affiliations. There was also the Moscow Youth Festival of 1957, at which contemporary Western abstraction was displayed. Events of this kind had a profound effect on non-conformist artists, which contributed to their being hounded by the art establishment, harassed by the authorities and, on occasions, roughed up by the KGB. The authorities assumed that the adoption of Western art forms and theories would lead to the adoption of Western social and political values. In a sense, of course, it did – and still does. Today many artists openly aspire to a dialogue with Western culture, and this is perhaps a measure of the social changes which have taken place in the USSR.

On a simple level, signs of this aspiration are visible in the stylistic influence of Western art movements on many artists. Because major exhibitions of contemporary Western art are still infrequent, information about its developments is culled largely from imported art journals which circulate informally from studio to studio. On a deeper level, what may be called an international outlook is reflected above all in the work of those artists who show a predominant interest in the intrinsic status and qualities of the art-object, quite apart from the traditional Russian concern for external ethical values. For an artist to take such an interest in the abstract and formal properties of art, the credo of Western modernism, was for a long time considered the height of bourgeois decadence.

Ivan Chuikov (born 1935) is one of the bulwarks of the unofficial art movement and one of the few artists of the older generation to have pursued convincingly such a line in his work. Educated in the 1950s at the Surikov Institute, it was not until the very end of the 1960s that he established substantial contacts with other artists of a similarly independent disposition. For Chuikov, as for many other non-conformist artists, participation in one of the seven linked exhibitions of unofficial art organized in 1976 in apartments and studios across Moscow was of great significance. The success of these exhibitions confirmed and strengthened him in his chosen path.

Chuikov has not shown himself interested in the development of a personal style along the paths of painterly technique. In common with the work of his contemporaries at the Surikov Institute, Kabakov and Bulatov, his painting has a conceptual orientation, and his concerns are to do

* Kamenny Most spans the Moscow river and leads to the Kremlin. It offers an excellent prospect to the west.

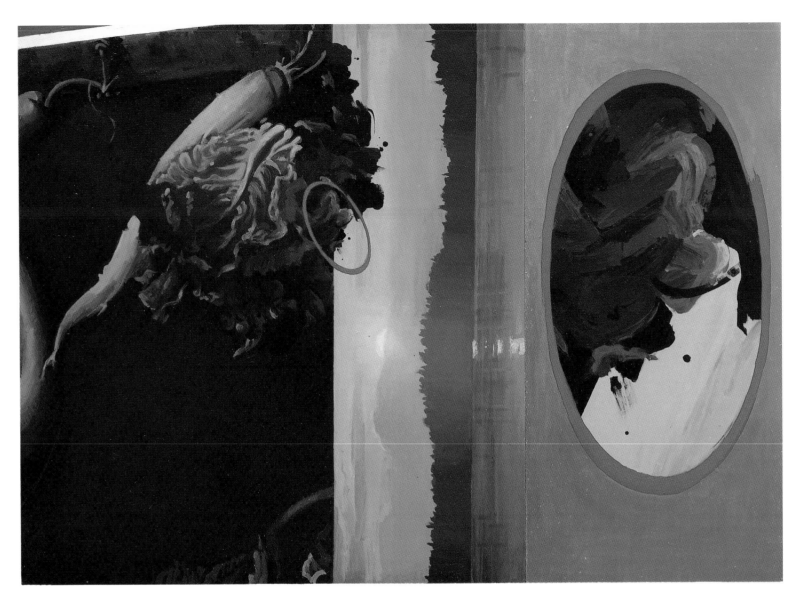

91. IVAN CHUIKOV. *Untitled.* 1987.
Enamel on hardboard, 180 × 130 cm (70¾ × 51⅛ in).
The artist

92. FRANCISCO INFANTE. *Cloud* installation, from the series *Sky Theatre*. 1986.
Mirror, earth, sky. Countryside near Moscow

with philosophical problems surrounding art itself. In the late 1960s he began to paint his *Windows* — works in which an image of some kind was painted over the physical structure of a window, thus creating a tension between a perception of the window as an object and the illusion of space created by the image painted on top of it. Since 1982 Chuikov's investigation of this essential ambiguity of a painting, its simultaneous existence as literal fact and as purveyor of illusion, has been carried out on a conventional flat surface, using free-flowing enamel paints with considerable virtuosity. Pictures in the series *Fragments* are assembled from visual quotations derived from a variety of already existing images [Pl. 91]. Characteristically, each quotation is considerably enlarged in relation to its source. Both in this, and in the fact that each quotation is spatially out of tune with its neighbours, consists the perceptual tension. It is an unavoidable tension between our reading of an area of the painting as pictorial illusion and, conflictingly, as a patch of paint.

The series of *Fragments* broadens the philosophical scope of Chuikov's work. By the act of replication, in sensuous licks of enamel paint which make us aware of the artist's role, the notion of authorship is nevertheless deliberately made ambiguous. What is more, by choosing his imagery from a variety of sources, Chuikov negates a conventional ranking of modes of visual representation, from high art downwards. He posits a kind of democracy of cultural values, a non-hierarchical pluralism.

Chuikov's acknowledgement of his position as a consumer (like all of us) of a vast amount of cultural information, from all epochs and quarters of society, is echoed in the work of Boris Smertin (born 1947). Smertin believes that a work of art should enshrine vastly differing orders of experience in order to arrive at some form of truth about existence. His assemblages are constructed, sometimes over many years, from found objects, paint and even other people's pictures. The latter, apparent for example in *Picture with a Portion of Sitnikov's Picture* [Pl. 95], even invites us to sample the imaginative world of a different artist altogether.

Smertin's art is, *par excellence*, an urban art, evoking a rummage through dustbins. It suggests a kind of personal archaeology, in which the various strata of an 'excavated' painting reveal the artist's successive affections and crazes, the forgotten presents his friends gave him, the changing face of the city in which he lives and works. Smertin's paintings themselves sometimes bear the marks of just such an excavation, a cutting away of the surface of a picture to reveal what was laid down years before. The way in which individual works of Smertin's keep evolving over the years, acquiring and shedding elements, suggests that for him real eloquence resides somewhere in the area between life and art, in the creative processes of construction and decay. Such an aesthetic, well-established in the West, finds relatively little support in Russia. The notion, central to Western consumer society, that goods are disposable does not have wide currency. An empty mineral-water bottle, for example, is not thrown away, nor chucked into a bottle-bank, but returned for a few kopecks' deposit.

Francisco Infante (born 1943) is also fascinated by aspects of experience that are essentially impermanent. The play of sunlight, the passage of clouds, the winter blanket of snow over the countryside round Moscow are all raw material for his photographic pieces. Of all Russian artists, it is perhaps Infante who has best succeeded in squaring the circle of the relationship of Russian to international culture. He has accomplished this by drawing on those aspects of Russian art — constructivism, suprematism — which have become part of the international heritage. Infante's involvement since the 1960s in kinetic art, large-scale happenings, installations and performance (all contemporary with the work of Western innovators in the same areas) derives from the dynamic and optimistic Russian art of the 1910s and 1920s, and in particular from the way it spilt over from the art gallery into architecture, the theatre and the environment.

Nowadays most of Infante's effort is put into the production of what he calls *artefakty*: sculptural

installations in the open air which exist only for so long as it takes for them to be photographed [Pl. 92]. These installations often use mirrors to reflect the surrounding environment and create in the resulting photograph the image of a space that confounds expectations. This is effectively a distant echo of the spatial ambiguity of constructivist sculpture. Infante's stress on the photographic image as the definitive form of his work indicates the contemplative response he requires, in which sensual stimuli are banished in favour of undisturbed reverie. In this sense, his work is an invitation to enter into a dream of the Russian landscape, a perennial subject with Russian artists. Indeed, Infante's work shows his fascination with the anecdotal, which is part of the joy of traditional landscape painting. The strict formal quality of his structures emphasizes the evanescent features – clouds, sunlight – of the surrounding environment.

Infante's world may be one of fleeting moments, but in his view these moments are by no means powerless. As a metaphor for the spiritual potency of his own art, its ability to make people look at the world with new eyes, he likes to adduce the experience recorded by Malevich – the time he caught momentary sight of a schoolboy's black satchel against the snow and received the inspiration for his *Black Square*. Infante's insertion of technology, i.e. photography and man-made structures, into the natural order in his search for a harmonic combination of the two is also an intimation of that technological Utopianism which once fired not only Malevich and his peers, but artists and thinkers across the world.

Like Infante, Irina Nakhova (born 1955) also delights in the highly formal manipulation of space. In this, she is more akin to many Western artists than to most of her Russian contemporaries. Her trademark is to fragment the visual unity of the physical world, as if the gaps and imponderable spaces which she opens up offered a more invigorating air to breathe. Once a year, Nakhova will take a number of weeks to transform a room in her apartment, where she creates a walk-in environment which exists in completed form for only a few days. Her transformation of the room, a kind of camouflage, destroys the spectator's perception of the solidity of objects and the co-ordinates of floor and walls. For a little while, the claustrophobia of Moscow existence – perhaps of Russian life as a whole – gives way to a fragile dream of escape [Pl. 93].

94. IGOR KOPYSTYANSKI. *Interior.* 1987. Oil on canvas. The artist

93. IRINA NAKHOVA. *Room, Installation No. 4.* 1987. Painted paper, furniture, objects, room. Moscow

95. BORIS SMERTIN.
Picture with a Portion of Sitnikov's Picture, from the series *Studies of the History of Art (Dedicated to the Artist Aleksandr Sitnikov)*. 1984. Mixed media, 84 × 57 cm (33 × 22½ in). The artist

96. SERGEI VOLKOV.
Untitled.
1987. Oil on canvas, 200 × 140 cm (78¾ × 55⅛ in). The artist

97. IRINA NAKHOVA.
Palace of Congresses.
1987. Oil on canvas,
140 × 200 cm
(55⅛ × 78¾ in).
The artist

The space in Nakhova's paintings echoes that of her 'rooms', and often has a similar metaphorical force, suggesting a flight from the relentless enclosure of everyday life. She interrupts architectural structures, depicted realistically, with passages of non-objective painting. In other pictures architectural fragments, often quotations from the ideal culture of the Renaissance, hover dislocated in abstract space. The painting *Palace of Congresses* [Pl. 97] shows how even a building accustomed to echo to the sound of Party rhetoric is not immune to this kind of spiritual transformation.

Nakhova's attempt to extract a statement from a tension between the purely painterly and the illustrative perhaps originates in the early period of her career, when she was influenced by Francis Bacon. It is, in a sense, an attempt to establish a creative dialectic between her background as a Russian artist, which involved a thorough training in realist painting and drawing, and the expressive possibilities inherent in non-objective art.

A similar attempt to acknowledge the academic tradition in an approach to art which is more than parochially credible in the late twentieth century is found in the work of Igor Kopystyanski (born 1954). Like Nakhova, he paints pictures and makes installations; but unlike her, he does not

98. IGOR
KOPYSTYANSKI.
*Damaged Painting
(Portrait) No. 5*
1987. Oil on canvas,
195 × 155 cm
(76¾ × 61 in).
Private collection

99. EVGENI MITTA. *Reminiscence.* 1987.
Oil on canvas, 160 × 220 cm (63 × 86½ in).
The artist

100. NATALIYA TURNOVA. *Onwards . . .* 1987.
Oil on canvas, 122 × 181 cm (48 × 71¼ in).
The artist

seem to have decided where the one activity ends and the other begins. Rooms swathed entirely in canvases, each one painted with an image that exudes nostalgia for the uncomplicated days of realism, are presented for our delectation [Pl. 94]. It is the kind of formal conceit popular among Western artists, but rare in Russia. Kopystyanski seems to be saying that if we can no longer put our faith in simple realist painting, because modernism has made us too aware of the canvas as object and the image as fiction, then perhaps we can be prevailed upon to trust it when it assumes the incontrovertibly real form of walls, floors, chairs and tables. While Nakhova uses art to dematerialize the physical world, Kopystyanski uses the physical world to rematerialize, however ironically, an art to which he is sentimentally attached.

Kopystyanski's series of restored pictures, elaborately battered and patched-together-again paintings, display the same infatuation with the past [Pl. 98]. They propose that we can preserve it only in a state of terminal decay. We are made to realize that the image of how people formerly lived and thought is irremediably distorted: we will never get more than a fragmented conception of it, one that is progressively obscured by the 'restorative' activities of each successive generation. Kopystyanski's equivocal paintings suggest as much about the present, and even the future, as about the past.

A quality of knowingness (apparent in Kopystyanski's work), a striving to dispense with the provincial air which afflicts many of the older generation who once looked West for inspiration, both are increasingly found in the work of young Russian artists. Sergei Volkov (born 1956) often uses images reduced to the schema of universally comprehensible signs [Pl. 96]. His desire for communication across frontiers, without let or hindrance, is emphasized by the absolutely mechanical nature of his knifed-on paint surfaces, which have shed the last vestige of individual personality. But, true Russian artist that he is, even a resolute internationalist like Volkov can spare time for a domestic gesture. Perhaps his best-known painting in Russia has the word *svoloch*, an emphatic term of abuse, written across it in foot-high letters, and nearly caused a riot when the morally upright students of Ilya Glazunov came across it at an exhibition.

The Russian artist's need to express his national identity does not always evaporate when he begins working in a style which has international currency. The work of Nataliya Turnova (born 1957) resembles Western decorative abstraction, although it is underpinned by a graphic verve which is characteristically Russian. She puts an explicitly Russian stamp on her paintings by including in them fragments of Russian words [Pl. 100] or popular Soviet imagery. This kind of 'labelling' of a work is a favourite ploy of artists, a significant refusal to relinquish a discrete Russian identity in art even now that it is permissible to do so.

The proper relationship of Russian to Western art is currently a matter of considerable debate in Russia itself. The Ministry of Culture, mindful of a chance to turn a quick dollar, has set up an art export salon catering to Western tastes. Sales are made in hard currency, of which so-called *valyuta* the artist normally receives only a percentage, the remainder being paid to him in the form of non-convertible roubles. But any proposition that Russia should participate on equal terms in the cultural life of the West provokes qualms in conservative circles. In fact, such a state of affairs is unlikely to obtain in the foreseeable future, because movement to and from the Soviet Union is so hedged about with restrictions that prevent artists and exhibitions from commuting with the requisite freedom and facility.

Be that as it may, the work of a recent batch of graduates from the Surikov Institute makes it clear that today's young artists do not have to endure the soul-searching of their parents' generation when faced with the blandishments of international culture, and this is a real change and improvement. Evgeni Mitta (born 1963) is an admirer of Francis Bacon. In constructions and installations he explores a broadly expressionist territory, while in his paintings he enjoys the same

101. AIDAN
SALAKHOVA.
Kiss!
1987. Oil on canvas,
240 × 160 cm
(94½ × 63 in). The artist

extreme tensions between facture and image as does Bacon [Pl. 99]. Aidan Salakhova (born 1964), scion of a hero of the Severe Style, makes paintings whose delight in decoration recalls both primitive art and the decadent era of Klimt, Schiele and the *Wiener Sezession* [Pl. 101]. That the leading American contemporary artist, Robert Rauschenberg, on a visit to Salakhova's studio in Moscow, was inspired to execute a painting for her on the spot, was perhaps a proleptic act of homage from the West to the new Russian art.

102. **COLLECTIVE ACTIONS**. *Performance, Russian World*. 1985.
Countryside near Moscow

103. **KATYA FILIPPOVA**. *Costume*. 1987.
Fashion Show, Sovetskaya Hotel, Moscow

NINE

THE PLAY'S THE THING

Performance art

Russians love a spectacle: from the Bolshoi ballet to the May Day parades they show an enthusiasm for public displays – rituals which derive, ultimately, from the elaborate ceremonial of Byzantium. Shakespeare goes down well, even in English. Russian performance art, like its Western equivalent, has its origins in the Futurist movement of the early twentieth century. Then, characters such as Mayakovski and the indefatigable self-publicist and painter, David Burlyuk (1882–1967), would parade through the streets of Moscow and St Petersburg in outlandish costumes and make-up. Yet performance art today has a tenuous hold in Russia. The reason for this is probably the suspicion of the authorities, and their opposition when faced by artists wanting to organize events independently, without official auspices. Such events, however innocuous, involve public assembly and the opportunity for unpredictable forms of social intercourse. Nowadays this opposition is milder than it was, but a situation still prevails in which artists who regard performance as their primary mode of self-expression are uncommon.

One exception to this rule is the performance group Collective Actions. They began to work together in the early 1970s, and may be regarded as the founders of contemporary Russian performance art. The complement of Collective Actions during the 1980s has consisted of seven people: Andrei Monastyrski, Georgi Kizevalter, Sergei Romashko, Nikita Alekseev, Nikolai Panitkov, Elena Elagina, Igor Makarevich. The name of the group is an acknowledgement of the strong Russian emphasis, both in the pre- and post-Revolutionary eras, on communal life. In a sense, the very phrase 'collective actions' ironically describes the means by which Communist society is supposed to work.

Perhaps as a conditioned reaction (or as a parody of such a reaction) to the opposition which they have had to overcome, Collective Actions make a virtue of reticence. They do not court the gallery-goer, but work in the streets and squares of Moscow and the countryside surrounding it [Pl. 102]. Even here their work is decidedly untheatrical and they prefer the neutral epithet 'action', rather than the loaded 'performance', as a description of it. As a rule, only invited spectators will be aware that an action is taking place, and even they will be ignorant of its parameters until it has finished. The involvement of these spectators, in one way or another, in the action itself, is an important feature of an action. Their unquestioning compliance with instructions is rewarded with a document thanking them for their participation – a satirical echo of the certificates of honour awarded to conscientious workers by the Soviet State.

This sense of social metaphor pervades the work of Collective Actions. Some actions, particularly those taking place in the countryside, explore atavistic rituals which lie beyond ideology. Central to these actions is the natural environment of forest or field, and the use of basic elements such as snow, fire and rain. Other actions make waves of a more topical nature. The first of

Three Urban Actions (1983), for example, involved spectators being shadowed by performers who made observations into tape-recorders almost in a parody of covert surveillance. Given the uncertain status of the group at the time, such behaviour could also be interpreted as counter-surveillance.

For all this metaphorical charge, actions are never explained, although they are exhaustively documented. Any interpretation of them is speculative; indeed, their content sometimes appears so gratuitous as to mock attempts to discern any sort of significance in them. Of course, in the Soviet context, an attempt to create an art which is exuberant but deliberately eschews meaning implies a questionable attitude to culture. The performance of collective actions which have no point to them is a piquant social gesture in a Communist society, whether one regards it as subversion of materialist striving or as the satirical apotheosis of the communal ideal.

Collective Actions exploit the same quality of calculated enigma as Ilya Kabakov. Like Kabakov's work, theirs is almost aggressively thought-provoking in its resistance to exegesis. The influence of Kabakov as a philosophical *éminence grise* is underlined by the *Kabakov Cupboard* [Pl. 104] made by Igor Makarevich (born 1943) of Collective Actions. Painted on the inside with a *trompe l'œil* portrait, the cupboard is an icon in yet another guise: it offers Makarevich perpetual access to Ilya Kabakov's genial spirit, while recalling one of Kabakov's best-known albums, in which the protagonist's adventures begin in a cupboard. The metaphor of a cupboard, suggesting a secret space or hiding place, may illuminate Collective Actions' striving. It is perhaps towards the creation of an 'alternative' space, mental as much as physical, in which life can be free of ideological interference.

The way in which Collective Actions' work resists attempts to extrapolate its meaning distils a whiff of the defiant spirit of nihilism, familiar to the West from Dostoevsky. This odour of nihilism, now, as then, arising from a deep disillusion with society, is more explicit in the performances of the *Avangardisty*, a group of young artists who chose their name in deference to the Russian art movements immediately after the Revolution. It indicates their desire to reanimate Russian art with some of the anarchic creativity of that era.

104. IGOR
MAKAREVICH.
Kabakov Cupboard.
1988. Wood and enamel,
200 × 60 × 50 cm
(78¾ × 23⅝ × 19⅝ in).
The artist

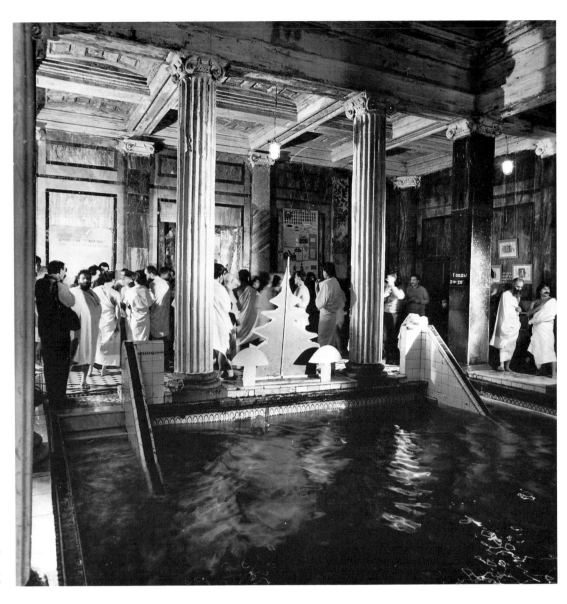

The complement of the *Avangardisty* includes Nikolai Zvezdochetov, Andrei Filippov, Sergei and Vladimir Mironenko, Sven Gundlakh, Yuri Albert and Vadim Zakharov. Some of them first came together in the late 1970s as a group called the *Mukhomory*, or Toadstools, a name which indicated the deliberate unpredictability and social unwholesomeness of their activities. Nowadays, under the auspices of their informal Club of Avant-gardists, they organize events which often involve a number of other artists.

The consistent butt of their satire is Soviet power. The sobriquet of 'The Third Rome' which Moscow took to itself after the fall of the Byzantine Church and State is used by them ironically at the expense of the Communist regime. They draw a parallel between a corrupt Roman Empire and the Soviet State, characterizing the latter as a place of venality, greed, intrigue and murder. One performance, in the form of a toga party [Pl. 105], was arranged in a Moscow *banya* – a grand, crumbling neo-classical building which of itself made the desired point about imperial decadence.

While the performances of the *Avangardisty* display a pleasure in *outré* behaviour for its own sake, their themes are not wilfully extravagant. The horrors of the Stalinist period at least are broadly acknowledged, as is the evidence of large-scale corruption under Brezhnev. So far, the *Avangardisty*

act largely within a context of broadly accepted ideas. Meanwhile, the Soviet State maintains its pronounced liking for ceremonial, for scarlet banners and martial music – indeed, for many of the same imperial trappings which so appealed to Stalin.

The *Avangardisty* are all painters and sculptors in their own right. Much of their work, such as the vicious-looking constructions of Andrei Filippov (born 1959) [Pl. 106], are often best viewed in the light of ideas provided by their performances. They form part of an overall statement, a strikingly theatrical satire on society [Pl. 108], imbued with that sense of history which gives substance to so much of Russian art.

106. ANDREI
FILIPPOV.
SPQR.
1988. Mixed media,
120 × 80 cm
(47¼ × 31½ in).
The artist

107. GERMAN
VINOGRADOV.
Performance.
1987. Moscow

There is a theatricality of a different kind in the work of German Vinogradov (born 1957). His performances are one-man spectacles [Pl. 107], often taking place in the cramped surroundings of a one-room flat, sometimes spilling over into the bathroom. Vinogradov is an accomplished musician and the composer of short pieces of music which he calls by the nonsense name 'bicaponias'. His performances are in effect a kind of chamber concert in which he plays a huge variety of *ad hoc* and home-made instruments. The often claustrophobic setting, the frequent use of fire and water, and the violent choreography of the action as a whole, which often takes place in among the audience, all make Vinogradov's performances a heart-stopping experience.

In contrast to the performances of the *Avangardisty*, which are seen as examples of political art directed towards society, Vinogradov's work is inward-looking, shamanistic. He is a disciple of Zen Buddhism. The Eastern emphasis on the inner, asocial self underlies his work. Paradoxically, he considers his first performance to have been an act of social significance: it was the time he spent one day banging a piece of metal around Red Square. The importance he attaches to that trivial gesture of mild hooliganism is perhaps the key to his art. Vinogradov's room and the noise which fills it, like his inscrutable act by the Kremlin walls, are the wilful expression of spiritual independence.

The exuberance of Vinogradov's work is echoed in performances commonly arranged nowadays to accompany the opening of exhibitions of work by young artists. These essentially theatrical events frequently take the form of a fashion show – at least of a kind, because the clothes displayed are usually impossible for everyday wear. Although the shows are celebratory, intended for entertainment, they are full of the kind of satirical social comment found in the work of the *Avangardisty*. Katya Filippova (born 1958) is an artist in a variety of media. She designs for the catwalk clothes which seem to blaspheme while daring you not to laugh [Pl. 103]. They draw on sacrosanct sartorial traditions – those of the Red Army and the Orthodox Church. Her combinations of military millinery and bondage gear, of dazzling nuptial gowns and twinkling candelabra hats, epitomize the attitude of irreverence towards once-inviolable symbols which is sweeping through Russian creative art today. In the intense struggle of ideologies, which some observers liken to a cultural civil war, we can hope that Filippova's bedizened damsels will have the last laugh.

108. SERGEI
MIRONENKO.
*The First Free Candidate
for President of the USSR.*
1988. Mixed media,
100 × 400 cm
(39⅜ × 157½ in).
The artist

'Swine. Look what
they've turned the
country into!'

THE ARTISTS

YURI ALBERT
Born 1959, Moscow. Studied 1977–80
at Pedagogical Institute, Moscow.
SELECTED EXHIBITIONS
AptArt and other exhibitions in
apartments 1970s–80s
1986 17th Young Artists' Exhibition,
Kuznetski Most, Moscow
1987 *Visual Artistic Culture*, Hermitage
Association, Moscow
1987 Retrospective Exhibition of
Moscow Artists, Hermitage Association,
Moscow
Exhibitions with the Club of Avant-
gardists since 1987
SELECTED BIBLIOGRAPHY
Flash Art, Milan, November–December
1987
Khudozhnik, no. 9, Moscow, 1987
E. A Peschler (ed.), *Künstler in Moskau*,
Schaffhausen, 1988

SERGEI BAZILEV
Born 1952, Kiev. Graduated from Kiev
Art Institute in 1977.
SELECTED EXHIBITIONS
Republican and All-Union exhibitions
since 1977
1984 *Young Artists of the Ukraine*, Central
House of the Artist, Moscow
SELECTED BIBLIOGRAPHY
Tvorchestvo, Moscow: no. 11, 1982; no.
7, 1985; no. 7, 1987
Iskusstvo, Moscow: no. 7, 1985; no. 1,
1988

GRIGORI BRUSKIN
Born 1945, Moscow. Graduated from
Moscow Institute of Technology in
1968.
SELECTED EXHIBITIONS
1984 One-man show, Central House of
Art-workers, Moscow
1987 *The Artist and Contemporaneity*,
Kashirskoe Shosse Exhibition Hall,
Moscow
1987 *OBJECT*, Malaya Gruzinskaya
Street Gallery, Moscow
1987 Retrospective Exhibition of
Moscow Artists, Hermitage Association,
Moscow
1988 Kunstmuseum, Bern

SELECTED BIBLIOGRAPHY
E. A. Peschler (ed.), *Künstler in Moskau*,
Schaffhausen, 1988
Catalogue, Kunstmuseum, Bern, 1988
Tvorchestvo, no. 7, Moscow, 1988

ERIK BULATOV
Born 1933, Sverdlovsk. Graduated from
Surikov Institute, Moscow, in 1958.
SELECTED EXHIBITIONS
1956 Second Exhibition of Young
Moscow Artists
1965 Kurchatov Institute for Nuclear
Physics, Moscow
1973 Galerie Dina Vierny, Paris
1977 Venice Biennale
1987 *The Artist and Contemporaneity*,
Kashirskoe Shosse Exhibition Hall,
Moscow
1988 One-man show: Kunsthalle,
Zurich; Portikus, Frankfurt;
Kunstverein, Bonn; Centre Pompidou,
Paris
SELECTED BIBLIOGRAPHY
A-Ya, no. 1, Paris, 1979
A-Ya, no. 3, Paris, 1981
E. A. Peschler (ed.), *Künstler in Moskau*,
Schaffhausen, 1988
Iskusstvo, no. 3, Moscow, 1988
Tvorchestvo, no. 7, Moscow, 1988

OLGA BULGAKOVA
Born 1951, Moscow. Graduated from
Surikov Institute, Moscow, in 1975.
SELECTED EXHIBITIONS
Moscow, Republican and All-Union
exhibitions since 1972
1979 Artists' Union Exhibition Hall,
Sofia, Bulgaria (Grand Prize)
1981 *3 Moscow Artists*, Central House of
the Artist, Moscow
1985 *Tradition and Search*, Grand Palais,
Paris
SELECTED BIBLIOGRAPHY
Tvorchestvo, no. 1, Moscow, 1980
Sovetskaya Zhivopis, no. 7, Moscow, 1986
Work in the State Tretyakov Gallery;
State Russian Museum; Ludwig
Collection, Cologne.

IVAN CHUIKOV
Born 1935, Moscow. Graduated from
Surikov Institute, Moscow, in 1960.
SELECTED EXHIBITIONS
1957 World Youth Festival, Moscow
1976 Exhibitions in apartments,
Moscow
1977 Venice Biennale
1987 *The Artist and Contemporaneity*,
Kashirskoe Shosse Exhibition Hall,
Moscow
1987 *OBJECT*, Malaya Gruzinskaya
Street Gallery, Moscow
1987 Retrospective Exhibition of
Moscow Artists, Hermitage Association,
Moscow
1987 Museum für Gegenwartskunst,
Basel
SELECTED BIBLIOGRAPHY
A-Ya, no. 1, Paris, 1979
A-Ya, no. 4, Paris, 1982
A-Ya, no. 6, Paris, 1984
E. A. Peschler (ed.), *Künstler in Moskau*,
Schaffhausen, 1988
Iskusstvo, no. 3, Moscow, 1988
Tvorchestvo, no. 7, Moscow, 1988

EVGENI DYBSKI
Born Konstanza, Rumania, 1955.
Graduated from Surikov Institute,
Moscow, in 1984.
SELECTED EXHIBITIONS
Moscow, Republican and All-Union
exhibitions since 1975
1987 Costakis Gallery, Athens
1987 *INTERART*, Poznan, Poland
1988 Studio Marconi, Milan
1988 Kunsthalle Stiftung Henri
Nannen, Emden, West Germany
SELECTED BIBLIOGRAPHY
Flash Art, Milan, October-November
1987
Catalogue, Costakis Gallery, Athens,
1987
Contemporary Russian Art, BBC TV
programme, 1987
Art and Design, London, September 1988
Work in the Novosibirsk Art Museum;
Ludwig Collection, Cologne.

SIMEN FAIBISOVICH
Born 1949, Moscow. Graduated from
Moscow Architectural Institute in 1972.
SELECTED EXHIBITIONS
15th and 16th Young Artists'
Exhibitions, Moscow
1987 Retrospective Exhibition of Moscow
Artists, Hermitage Association, Moscow
1987 Phyllis Kind Gallery, New York
1988 Phyllis Kind Gallery, New York

ANDREI FILIPPOV
Born 1959, Petropavlovsk. Graduated
from Scenographic Faculty, Moscow
Arts Theatre Institute, in 1982.
SELECTED EXHIBITIONS
AptArt and other exhibitions in
apartments 1970s–80s
1987 *Visual Artistic Culture*, Hermitage
Association, Moscow
1987 Retrospective Exhibition of
Moscow Artists, Hermitage Association,
Moscow
Exhibitions with the Club of Avant-
gardists since 1987
SELECTED BIBLIOGRAPHY
Durch 2, Graz, 1987
E. A. Peschler (ed.), *Künstler in Moskau*,
Schaffhausen, 1988

KATYA FILIPPOVA
Born 1958, Moscow. Graduated from
Polygraphic Institute, Moscow, in 1981.
SELECTED FASHION SHOWS
1987 Retrospective Exhibition of
Moscow Artists, Hermitage Association,
Moscow
1987 Sovetskaya Hotel, Moscow
SELECTED BIBLIOGRAPHY
Start, Belgrade, January 1988
Popular Moscow Culture, BBC TV
programme, 1987

IGOR GANIKOVSKI
Born 1950, Moscow. Graduated from
Moscow Institute of Steel and Alloys in
1972.
SELECTED EXHIBITIONS
Moscow, Republican and All-Union
exhibitions since c.1975
1986 17th Young Artists' Exhibition,
Kuznetski Most, Moscow

1988 One-man show, Galerie Beylin, Helsinki
1988 Bologna Art Fair
1988 Galerie Poll, West Berlin
SELECTED BIBLIOGRAPHY
Symphony of Shostakovich, Finnish TV programme, 1988
Taid, Helsinki, April 1987

Work in the Museum of Contemporary Art, Poznan, Poland; National Gallery, Warsaw; Ludwig Collection, Cologne; Kunststiftung Nannen, Emden, West Germany.

FRANCISCO INFANTE
Born 1943, Vasilevka, Saratov. Graduated from the art school attached to Surikov Institute, Moscow, in 1961.
SELECTED EXHIBITIONS
1963 Central House of Art-workers, Moscow
1968 Dokumenta, Kassel
1977 Venice Biennale
1987 *The Artist and Contemporaneity*, Kashirskoe Shosse Exhibition Hall, Moscow
1987 *OBJECT*, Malaya Gruzinskaya Street Gallery, Moscow
1987 Retrospective Exhibition of Moscow Artists, Hermitage Association, Moscow
SELECTED BIBLIOGRAPHY
A-Ya, no. 1, Paris, 1979
A-Ya, no. 3, Paris, 1981
E. A. Peschler (ed.), *Künstler in Moskau*, Schaffhausen, 1988

VIKTOR IVANOV
Born 1924, Moscow. Graduated from Surikov Institute, Moscow, in 1950.
ONE-MAN EXHIBITIONS
1974–5 Ryazan, Vologda, Kirov, Perm, Sverdlovsk, Tyumen
1976 Central House of the Artist, Moscow
1976–7 Leningrad, Kiev, Kishinev, Smolensk, Vladmir, Gorki, Tula, Sochi, Stavropol, Taganrog, Rostov-on-Don, Saratov
1984 Central House of the Artist, Moscow
SELECTED BIBLIOGRAPHY
Catalogue, Central House of the Artist, Moscow, 1985
Sovetskaya Zhivopis, no. 7, Moscow

Work in the State Tretyakov Gallery; State Russian Museum; Uffizi Gallery, Florence; many Soviet museums.

ILYA KABAKOV
Born Dnepropetrovsk, 1933. Graduated from Surikov Institute, Moscow, 1957.
SELECTED EXHIBITIONS
1962 Belyutin Studio Group, Moscow
1977 *Unofficial Art from the Soviet Union*, Institute of Contemporary Arts, London
1985 *Ilya Kabakov*, Kunsthalle, Bern
1986 Centre National des Arts Plastiques, Paris
1987 Museum für Gegenwartskunst, Basel

1988 One-man show, Ronald Feldman, New York
SELECTED BIBLIOGRAPHY
A-Ya, no. 2, Paris, 1980
A-Ya, no. 6, Paris, 1984
Catalogue, Kunsthalle, Bern, 1985
Catalogue, Centre National des Arts Plastiques, Paris, 1986
Flash Art, Milan, February 1986
Flash Art, Milan, November 1987
Contemporary Russian Art, BBC TV, 1987

MAKSIM KANTOR
Born 1957, Moscow. Graduated from Polygraphic Institute, Moscow, in 1980.
SELECTED EXHIBITIONS
1986 17th Young Artists' Exhibition, Kuznetski Most, Moscow
1987 *Youth of the Country*, Manezh Gallery, Moscow
1987 *War and Peace*, Munich, Hamburg, Moscow and Leningrad
1988 Studio Marconi, Milan
SELECTED BIBLIOGRAPHY
Tvorchestvo, no. 7, Moscow, 1986
Tvorchestvo, no. 8, Moscow, 1987
Burlington Magazine, London, March 1989

Work in the Ministry of Culture, Moscow; Kunststiftung Nannen, Emden, West Germany.

GEORGI KIZEVALTER
Born 1955, Moscow. Graduated from Moscow Teacher Training Institute, 1977.
SELECTED EXHIBITIONS
AptArt and other exhibitions in apartments 1970s–80s
1986 17th Young Artists' Exhibition, Kuznetski Most, Moscow
1986 New Museum of Contemporary Art, New York
SELECTED BIBLIOGRAPHY
Flash Art, no. 76/7, Milan, 1977
AptArt – Moscow Vanguard in the 80s, St. Mary's College of Maryland, 1985
Flash Art, Milan, November 1987

Work in the Kunsthalle, Bern; Contemporary Russian Art Center, New York; Norton Dodge Collection.

SVETLANA KOPYSTYANSKAYA
Born 1950, Voronezh. Graduated from Faculty of Architecture, Polytechnic Institute, Lvov.
SELECTED EXHIBITIONS
1987 *OBJECT*, Malaya Gruzinskaya Street Gallery, Moscow
1988 Contemporary Art Museum, Helsinki
SELECTED BIBLIOGRAPHY
Catalogue, Contemporary Art Museum, Helsinki, 1988

IGOR KOPYSTYANSKI
Born 1954, Lvov. Graduated from Institute of Applied and Decorative Arts, Lvov.
SELECTED EXHIBITIONS
1987 *OBJECT*, Malaya Gruzinskaya Street Gallery, Moscow

1987 Paris FIAC 87, Galerie de France
1988 Madrid ARCO 88, Galerie de France
SELECTED BIBLIOGRAPHY
Flash Art, Milan, November–December 1987
Catalogue, Paris FIAC 87, Galerie de France
Catalogue, Madrid ARCO 88, Galerie de France

YURI KOROLEV
Born 1929, Moscow. Graduated from Mukhina Art School, Leningrad, 1955.

Moscow, Republican and All-Union exhibitions since 1949
SELECTED BIBLIOGRAPHY
Moskovskie Monumentalisty, Sovetski Khudozhnik, Moscow, 1985

Work in the State Tretyakov Gallery; State Russian Museum; other museums in the USSR.

ANATOLI KULINICH
Born 1949, Sumskaya Oblast, Ukraine. Graduated from Moscow art school 'In Memory of 1905' in 1970.

Exhibitions in Moscow, Leningrad and other cities of the USSR; Dortmund (1981); Helsinki (1981); East Berlin (1988)

Work in the Pushkin Museum, Moscow; Ministry of Culture, Moscow; many regional museums in the USSR.

IRINA LAVROVA
Born 1931, Bolshevo, Moskovskaya Oblast. Graduated from Stroganov Art School, Moscow, in 1956.

Many exhibitions in the USSR and abroad
SELECTED BIBLIOGRAPHY
Moskovskie Monumentalisty, Sovetski Khudozhnik, Moscow, 1985
Irina Lavrova, Igor Pchelnikov, Sovetski Khudozhnik, Moscow, 1985

Work in the State Russian Museum; museums in Alma-Ata, Perm, Omsk; Ludwig Collection, Cologne. Monumental works include those in the Soviet Embassy, Paris; Moskva Restaurant, Moscow; Oktyabryaskaya Restaurant, Moscow; Karpatskie Uzory Restaurant, Moscow; Yuzhny Sanatorium, Crimea.

IVAN LUBENNIKOV
Born 1951, Minsk. Graduated from Surikov Institute, Moscow, in 1976.
SELECTED EXHIBITIONS
Moscow, Republican and All-Union exhibitions since 1972
1986 Künstlerhaus Bethanien, West Berlin
1988 Studio Marconi, Milan
1988 One-man show, Kashirskoe Shosse Exhibition Hall, Moscow
SELECTED BIBLIOGRAPHY
Moskovskie Monumentalisty, Sovetski Khudozhnik, Moscow, 1985

Exhibition catalogue, Kashirskoe Shosse Exhibition Hall, Moscow, 1988

Work in the Ludwig Collection, Cologne. Monumental work includes Soviet Memorial at the Auschwitz Concentration Camp; Taganka Theatre, Moscow; Kombinat *Trekhgornaya Manufaktura*, Moscow.

IGOR MAKAREVICH
Born 1943, Tbilisi. Graduated from Institute of Cinematography, Moscow, in 1968.

Moscow, Leningrad, Republican and All-Union exhibitions since 1970
SELECTED BIBLIOGRAPHY
A-Ya, no. 1, Paris, 1979
A-Ya, no. 3, Paris, 1981
A-Ya, no. 4, Paris, 1982
Moskovskie Monumentalisty, Sovetski Khudozhnik, Moscow, 1985

Works in the State Tretyakov Gallery; State Russian Museum; Ludwig Collection, Cologne.

BORIS MILYUKOV
Born 1917, Tula. Graduated from Moscow Institute of Applied and Decorative Art in 1952.
SELECTED EXHIBITIONS
Moscow, Republican and All-Union exhibitions since 1953
1977 & 1987 One-man shows, Central House of the Artist, Moscow.

Monumental works include ceiling in the club of *Kompressor* Factory, Moscow; *Varshava* Banqueting Hall, Moscow; Planetarium, Leningrad; façade of State Union Project Institute, Moscow; decorative sculpture in front of Intourist Hotel, Moscow.

SERGEI MIRONENKO
Born 1959, Moscow. Graduated from Faculty of Stage Management, Moscow Arts Theatre Institute.
SELECTED EXHIBITIONS
1978 *Experiment*, Malaya Gruzinskaya Street Gallery
AptArt exhibitions from 1982
1986 *Laboratory* at the 17th Young Artists' Exhibition, Kuznetski Most, Moscow
1987 Retrospective Exhibition of Moscow Artists, Hermitage Association, Moscow
1988 Kuznetski Most, Moscow

EVGENI MITTA
Born 1963, Moscow. Graduated from Surikov Institute, Moscow, in 1988.
SELECTED EXHIBITIONS
1986 17th Young Artists' Exhibition, Kuznetski Most, Moscow
1987 *Youth of the Country*, Manezh Gallery, Moscow
1988 Bologna Art Fair

EVSEI MOISEENKO
Born 1916, Uvarovich, Belorussia. Died 1988, Leningrad. Studied 1936–41 at Academy of Arts, Leningrad.

SELECTED EXHIBITIONS
Moscow, Leningrad, Republican and
All-Union exhibitions since 1948
1974 Grand Palais, Paris
1985 One-man show, Russian Museum,
Leningrad
SELECTED BIBLIOGRAPHY
Evsei Moiseenko, Aurora, Moscow, 1975
Evsei Moiseenko, Sovetski Khudozhnik,
Moscow, 1981

Work in the State Tretyakov Gallery;
State Russian Museum; regional
museums of the USSR.

ANDREI MYLNIKOV
Born 1919, Pokrovsk. Graduated from
Academy of Arts, Leningrad, in 1947.
SELECTED EXHIBITIONS
Leningrad, Republican and All-Union
exhibitions since 1946
1947 *30 Years of Soviet Power*, Moscow
1958 *200 Years of the Academy of Arts*,
Moscow
1960 Venice Biennale
1987 Jubilee exhibition of the Academy
of Arts, New Tretyakov Gallery, Moscow
SELECTED BIBLIOGRAPHY
V. Brek, *A. Mylnikov*, Leningrad, 1960
A. Kaganovich, *A. Mylnikov*, Leningrad,
1980
Sovetskaya Zhivopis, no. 7, Moscow, 1986

Work in the State Tretyakov Gallery;
State Russian Museum; other museums
in the USSR. Monumental works
include those in the House of
Architects, Leningrad (1947); Leningrad
metro station *Vladimirskaya* (1955);
Lenin, Safety Curtain, Palace of
Congresses, Moscow (1961).

IRINA NAKHOVA
Born 1955, Moscow. Graduated from
Polygraphic Institute, Moscow, in 1978.
SELECTED EXHIBITIONS
Moscow, Republican and All-Union
exhibitions since 1975
1987 *Visual Artistic Culture*, Hermitage
Association, Moscow
1987 Retrospective Exhibition of
Moscow Artists, Hermitage Association,
Moscow
1988 Contemporary Art Museum,
Helsinki
1988 Kunstmuseum, Bern
SELECTED BIBLIOGRAPHY
Catalogue, Studio Marconi, Milan,
1988
Catalogue, Contemporary Art Museum,
Helsinki, 1988

TATYANA NAZARENKO
Born 1944, Moscow. Graduated from
Surikov Institute, Moscow, in 1968.
SELECTED EXHIBITIONS
Moscow, Republican and All-Union
exhibitions since 1966
1986 Künstlerhaus Bethanien, West
Berlin
1987 Leverkusen, East Germany
1988 Bremen, East Germany
1989 Berkeley Square Gallery, London

SELECTED BIBLIOGRAPHY
Sovetskaya Zhivopis, no. 5, Moscow, 1983
Catalogue, *Tatyana Nazarenko*, Sovetski
Khudozhnik, Moscow, 1987

Work in the State Tretyakov Gallery;
State Russian Museum; regional
museums of the USSR; Ludwig
Collection, Cologne.

NATALIYA NESTEROVA
Born 1944, Moscow. Graduated from
Surikov Institute, Moscow, in 1968.
SELECTED EXHIBITIONS
Moscow, Republican and All-Union
exhibitions since 1966
1981 *ART 81*, Basel
1986 Künstlerhaus Bethanien, West
Berlin
1987 Paris FIAC 87, Galerie de France
1988 Nakhamkin Gallery, New York
SELECTED BIBLIOGRAPHY
'Nataliya Nesterova', in series
New Names: Contemporary Artists, Moscow,
1981
Sovetskaya Zhivopis, no. 7, Moscow, 1986
Modern Painters, vol. 2, no. 1, London,
February 1989

Work in the State Tretyakov Gallery;
State Russian Museum; regional
museums of the USSR; Ludwig
Collection, Cologne.

BORIS ORLOV
Born 1941, Moscow. Graduated from
Stroganov Art School, Moscow, in 1965.
SELECTED EXHIBITIONS
1968 Young Artists' Exhibition,
Kuznetski Most, Moscow
1970s Exhibitions in apartments,
Moscow
1987 *The Artist and Contemporaneity*,
Kashirskoe Shosse Exhibition Hall,
Moscow
1987 Retrospective Exhibition of
Moscow Artists, Hermitage Association,
Moscow
SELECTED BIBLIOGRAPHY
A-Ya, no. 1, Paris, 1979
E. A. Peschler (ed.), *Künstler in Moskau*,
Schaffhausen, 1988

NIKOLAI OVCHINNIKOV
Born 1958, Moscow. Graduated from
Moscow art school 'In Memory of 1905'
in 1978.
SELECTED EXHIBITIONS
1986 17th Young Artists' Exhibition,
Kuznetski Most, Moscow
1987 *The Artist and Contemporaneity*,
Kashirskoe Shosse Exhibition Hall,
Moscow
1987 Retrospective Exhibition of
Moscow Artists, Hermitage Association,
Moscow
1988 Madrid ARCO 88, Galerie de
France
SELECTED BIBLIOGRAPHY
E. A. Peschler (ed.), *Künstler in Moskau*,
Schaffhausen, 1988

IGOR PCHELNIKOV
Born 1931, Moscow. Graduated from
Mukhina art school, Leningrad, in 1956.

Moscow, Republican and All-Union
exhibitions since 1957
SELECTED BIBLIOGRAPHY
Moskovskie Monumentalisty, Sovetski
Khudozhnik, Moscow, 1985
Irina Lavrova, Igor Pchelnikov, Sovetski
Khudozhnik, Moscow, 1985

Work in the State Russian Museum;
museums in Perm and Omsk; Costakis
Gallery, Athens. Monumental works
include those in the Soviet Embassy,
Paris; Oktyabryaskaya Restaurant,
Moscow; Yuzhny Sanatorium, Crimea;
Moskva Restaurant, Moscow; Sadko
Café, Moscow.

ARKADI PETROV
Born Gorlovka, Donbass, 1940.
Graduated from Surikov Institute,
Moscow, in 1969.
SELECTED EXHIBITIONS
1984 One-man show, Exhibition Hall,
Balikova Street, Moscow
1987 Retrospective Exhibition of
Moscow Artists, Hermitage Association,
Moscow
1988 One-man show, MELZ Palace of
Culture, Moscow
SELECTED BIBLIOGRAPHY
E. A. Peschler (ed.), *Künstler in Moskau*,
Schaffhausen, 1988

Work in the State Russian Museum;
Ludwig Collection, Cologne.

DMITRI PRIGOV
Born 1940, Moscow. Graduated from
Stroganov Art School, Moscow, in 1967.
SELECTED EXHIBITIONS
1987 *The Artist and Contemporaneity*,
Kashirskoe Shosse Exhibition Hall,
Moscow
1987 Retrospective Exhibition of
Moscow Artists, Hermitage Association,
Moscow
1987 *Dokumenta*, Kassel
SELECTED BIBLIOGRAPHY
A-Ya, no. 2, Paris, 1980
Modern Painters, vol. 2, no. 1, London,
February 1989

Work in the Elvejem Museum, Madison,
Wisconsin; Kunstmuseum, Bern.

SERGEI PRISEKIN
Born 1958, Moscow. Graduated from
Surikov Institute, Moscow, in 1983.

Moscow, Republican and All-Union
exhibitions since 1976, and
international exhibitions
SELECTED BIBLIOGRAPHY
Tvorchestvo, no. 7, Moscow, 1986
Art Monthly, London, April 1988
Art and Design, London, September 1988

Work in the Museum of Armed Might,
Moscow; museums in Leningrad and
Vladivostock; Soviet Embassy, Paris.

ANDREI ROITER
Born 1960, Moscow.
SELECTED EXHIBITIONS
1977 Malaya Gruzinskaya Street
Gallery, Moscow
1986 17th Young Artists' Exhibition,
Kuznetski Most, Moscow
1987 *The Artist and Contemporaneity*,
Kashirskoe Shosse Exhibition Hall,
Moscow
1987 *Visual Artistic Culture*, Hermitage
Association, Moscow
1987 *Youth of the Country*, Manezh
Gallery, Moscow
1987 Retrospective Exhibition of
Moscow Artists, Hermitage Association,
Moscow
Exhibitions with the Club of Avant-
gardists since 1987
SELECTED BIBLIOGRAPHY
Durch 2, Graz, 1987
Contemporary Russian Art, BBC TV, 1987
E. A. Peschler (ed.), *Künstler in Moskau*,
Schaffhausen, 1988

TAIR SALAKHOV
Born 1928, Baku. Graduated from
Surikov Institute, Moscow, in 1957.
SELECTED EXHIBITIONS
Moscow, Republican and All-Union
exhibitions since 1952
1961 One-man show, Baku
1986 Art of Azerbaijan, Central House
of the Artist, Moscow
1987 Jubilee exhibition of the Academy
of Arts, New Tretyakov Gallery,
Moscow
SELECTED BIBLIOGRAPHY
Tair Salakhov, Sovetski Khudozhnik,
Moscow, 1986

Work in the State Tretyakov Gallery;
State Russian Museum; other museums
in the USSR.

AIDAN SALAKHOVA
Born 1964, Moscow. Graduated from
Surikov Institute, Moscow, in 1987.
SELECTED EXHIBITIONS
1986 17th Young Artists' Exhibition,
Kuznetski Most, Moscow
1987 *Youth of the Country*, Manezh
Gallery, Moscow
1987 *War and Peace*, Munich, Hamburg,
Moscow and Leningrad
1988 *Man, Family, Society*, USA
SELECTED BIBLIOGRAPHY
Catalogue, *War and Peace*, Central
House of the Artist, Moscow, 1988

EDVARD SHTEINBERG
Born 1937, Moscow.
SELECTED EXHIBITIONS
Moscow, Republican and All-Union
exhibitions since 1961
1975 Bee-keeping pavilion, VDNKh
Park, Moscow
1981 *Moscow–Paris*, Central House of
the Artist, Moscow; Centre Georges
Pompidou, Paris
1987 One-man show, Hermitage
Association, Moscow

1988 One-man show, Galerie Claude Bernard, Paris
SELECTED BIBLIOGRAPHY
A-Ya, no. 3, Paris, 1982
Catalogue, *Edward Steinberg*, Zentrum für interdisziplinare Forschung, Bielefeld, 1983
Catalogue, Museum Bochum, 1985
E. A. Peschler (ed.), *Künstler in Moskau*, Schaffhausen, 1988

SERGEI SHUTOV
Born 1955, Potsdam, East Germany.
SELECTED EXHIBITIONS
1986 17th Young Artists' Exhibition, Kuznetski Most, Moscow
1987 *Visual Artistic Culture*, Hermitage Association, Moscow
1987 Retrospective Exhibition of Moscow Artists, Hermitage Association, Moscow
1988 MELZ Palace of Culture, Moscow
1988 Thumb Gallery, London
SELECTED BIBLIOGRAPHY
Contemporary Russian Art, BBC TV programme, 1987

MIKHAIL SHVARTSMAN
Born 1926, Moscow. Graduated from Stroganov Institute, Moscow, in 1956.
Many Moscow, Republican and All-Union exhibitions since 1950s
SELECTED BIBLIOGRAPHY
A-Ya, no. 6, Paris, 1984
Work in collections in the USSR and abroad.

ANATOLI SLEPYSHEV
Born 1932, Moscow. Graduated from Surikov Institute, Moscow, in 1965.
Moscow, Republican and All-Union exhibitions since 1960s
Work in the State Tretyakov Gallery; State Russian Museum; public collections in Istra, Arkhangelsk, Ryazan; National Gallery, East Berlin; Ludwig Collection, Cologne.

BORIS SMERTIN
Born 1947. Graduated from Surikov Institute, Moscow, in 1973.
SELECTED EXHIBITIONS
Moscow, Republican and All-Union exhibitions
1979 First European Graphics Biennale, West Germany
1981 European Graphics Triennial, Venice
1988 *No Fourth Man*, Palace of Culture, Tekstilshchiki, Moscow
Work in the State Tretyakov Gallery; Central Museum of Cosmonautics.

ALEKSEI SUNDUKOV
Born 1952, Kubishevskaya Oblast. Graduated from Stroganov Art School, Moscow, in 1982.
SELECTED EXHIBITIONS
1986 17th Young Artists' Exhibition, Kuznetski Most, Moscow

1987 *Youth of the Country*, Manezh Gallery, Moscow
1987 Retrospective Exhibition of Moscow Artists, Hermitage Association, Moscow
SELECTED BIBLIOGRAPHY
Tvorchestvo, no. 7, Moscow, 1986
Culture and Life, no. 1, Moscow, 1988
Contemporary Russian Art, BBC TV, 1987
Burlington Magazine, London, March 1989

ILYA TABENKIN
Born 1914, Mozyr. Graduated from Surikov Institute, Moscow, in 1949.
ONE-MAN EXHIBITIONS
1979 Kuznetski Most, Moscow
1983 Palace of Art Workers, Vilnius
SELECTED BIBLIOGRAPHY
Sovetskaya Zhivopis, no. 8, Moscow, 1986
Contemporary Russian Art, BBC TV, 1987
Modern Painters, vol. 2, no. 1, London, February 1989
Work in the State Tretyakov Gallery; State Russian Museum; public collections in Bryansk, Tbilisi, Petrozavodsk, Perm, Rostov-Yaroslav Preserve.

LEV TABENKIN
Born 1952, Moscow. Graduated from Polygraphic Institute, Moscow, in 1975.
SELECTED EXHIBITIONS
Moscow, Republican and All-Union exhibitions since 1974
1986 17th Young Artists' Exhibition, Kuznetski Most, Moscow
1987 *Youth of the Country*, Manezh Gallery, Moscow
1988 Studio Marconi, Milan
SELECTED BIBLIOGRAPHY
Tvorchestvo, no. 7, Moscow, 1986
Contemporary Russian Art, BBC TV, 1987
Burlington Magazine, London, March 1989
Work in the State Art Museum, Novosibirsk; State Art Museum, Sumi, Ukraine.

DMITRI TSYKALOV
Born 1963, Moscow. Graduated from Polygraphic Institute, Moscow, in 1988.
SELECTED EXHIBITIONS
1984 2nd All-Union Drawing Exhibition, Central House of the Artist, Moscow
1987 *Visual Artistic Culture*, Hermitage Association, Moscow
1988 Studio Marconi, Milan

NATALIYA TURNOVA
Born 1957, Kabul. Graduated from Stroganov Art School, Moscow, in 1983.
SELECTED EXHIBITIONS
1985 Malaya Gruzinskaya Street Gallery, Moscow
1986 17th Young Artists' Exhibition, Kuznetski Most, Moscow
1987 Retrospective Exhibition of Moscow Artists, Hermitage Association, Moscow
1988 Thumb Gallery, London

SELECTED BIBLIOGRAPHY
Iskusstvo, no. 5, Moscow, 1987

OLEG VASILEV
Born 1931, Moscow. Graduated from Surikov Institute, Moscow, in 1958.
SELECTED EXHIBITIONS
Moscow, Republican and All-Union exhibitions since 1956
1982 *Art and Photography*, Centre for Technical Aesthetics, Moscow
1987 Retrospective Exhibition of Moscow Artists, Hermitage Association, Moscow
1987 Phyllis Kind Gallery, New York
1988 Studio Marconi, Milan
1988 Kunstmuseum, Bern
SELECTED BIBLIOGRAPHY
A-Ya, no. 2, Paris, 1980

GERMAN VINOGRADOV
Born 1957, Moscow.
SELECTED EXHIBITIONS
1987 *OBJECT*, Malaya Gruzinskaya Street Gallery, Moscow
1987 Retrospective Exhibition of Moscow Artists, Hermitage Association, Moscow
1988 *Troe*, Art Museum, Tomskaya Oblast, RSFSR
SELECTED BIBLIOGRAPHY
Contemporary Russian Art, BBC TV programme, 1987

ANDREI VOLKOV
Born 1948, Moscow. Graduated from Stroganov Art School, Moscow, in 1971.
SELECTED EXHIBITIONS
Moscow, Republican and All-Union exhibitions since c.1970
1985 *Tradition and Search*, Grand Palais, Paris (Gold Medal)
1985 *Tradition and Contemporaneity*: Düsseldorf, Stuttgart, Hanover
SELECTED BIBLIOGRAPHY
Sovetskaya Zhivopis, Moscow, 1979
Yunost, no. 7, Moscow, 1980
Tvorchestvo, no. 10, Moscow, 1980
Iskusstvo, no. 6, Moscow, 1983
Work in the State Tretyakov Gallery; USSR Union of Artists; Ministry of Culture, Moscow; Ludwig Collection, Cologne.

SERGEI VOLKOV
Born Kazan, 1956. Graduated from Architecture Department, Kazan Building Institute, in 1980.
SELECTED EXHIBITIONS
1986 17th Young Artists' Exhibition, Kuznetski Most, Moscow
1987 *Visual Artistic Culture*, Hermitage Association, Moscow
1987 Phyllis Kind Gallery, New York
1987 Paris FIAC 87, Galerie de France
1988 Madrid ARCO 88, Galerie de France

VLADIMIR YANKILEVSKI
Born 1938, Moscow. Graduated from Polygraphic Institute, Moscow, in 1962.

SELECTED EXHIBITIONS
1962 Belyutin Studio Group, Moscow
1962 *Thirty Years of MOSKh*, Manezh Gallery, Moscow
1962 (with Ernst Neizvestny) Moscow University
1978 Malaya Gruzinskaya Street Gallery
1987 One-man show, Malaya Gruzinskaya Street Gallery
1988 One-man show, Nakhamkin Gallery, New York
SELECTED BIBLIOGRAPHY
A-Ya, no. 3, Paris, 1981
Catalogue, Museum Bochum, 1985
Zeitschrift für Gegenwartsfragen des Ostens, Sonderdruck, 1987

VADIM ZAKHAROV
Born Dushanbe, 1959. Graduated from Pedagogical Institute, Moscow, in 1983.
SELECTED EXHIBITIONS
AptArt, Moscow and USA, and other exhibitions in apartments 1970s–80s
Exhibitions with the Club of Avant-gardists since 1987
1986 17th Young Artists' Exhibition, Kuznetski Most, Moscow
1987 *Visual Artistic Culture*, Hermitage Association, Moscow
1987 Retrospective Exhibition of Moscow Artists, Hermitage Association, Moscow
1988 Madrid ARCO 88, Galerie de France
1988 Kunstmuseum, Bern
SELECTED BIBLIOGRAPHY
Flash Art, Milan, November 1987
Durch 2, Graz, 1987
E. A. Peschler (ed.), *Künstler in Moskau*, Schaffhausen, 1988

IRINA ZATULOVSKAYA
Born 1954, Moscow. Graduated from Polygraphic Institute, Moscow, in 1976.
SELECTED EXHIBITIONS
1987 *Visual Artistic Culture*, Hermitage Association, Moscow
1987 369 Gallery, Edinburgh
1987 Warwick Arts Trust, London
1988 *Troe*, Art Museum, Tomskaya Oblast, RSFSR
SELECTED BIBLIOGRAPHY
Sovetskaya Zhivopis, no. 8, Moscow, 1986
Contemporary Russian Art, BBC TV programme, 1987
Work in museums in Novosibirsk, Rostov-on-Don, Novokuznetsk; National Gallery, Warsaw.

DMITRI ZHILINSKI
Born 1928. Graduated from Surikov Institute, Moscow, in 1951.
Moscow, Republican and All-Union exhibitions since 1951.
SELECTED BIBLIOGRAPHY
P. A. Pavlov, *Dmitri Zhilinski*, Leningrad, 1974
Work in the State Tretyakov Gallery; State Russian Museum; Ludwig Collection, Cologne.

BIBLIOGRAPHY

HISTORICAL

A. Bird, *A History of Russian Painting*, Oxford, 1987

J. Bowlt, *Russian Art of the Avant-Garde: Theory and Criticism 1902–34*, New York, 1976

I. Grabar, V. Kemenov, and V. Lazarev, *Istoriya Russkogo Iskusstva*, 13 vols., Moscow, 1953–69

C. Gray, *The Great Experiment, Russian Art*, London 1962; reissued as *The Russian Experiment in Art 1863–1922*, London, 1986

B.M. Nikiforov, *Kurzer Abriss der Geschichte der soujetischen Malerei von 1917 bis 1945*, Dresden, 1953

J.C. Vaughan, *Soviet Socialist Realism: Origins and Theory*, London, 1973

V.M. Zimenko, *The Humanism of Art*, Moscow, 1984

CONTEMPORARY

C. Doria (ed.), *Russian Samizdat Art*, New York, 1986

I. Golomshtok and A. Glezer, *Unofficial Art from the Soviet Union*, London, 1977

E. Peschler (ed.), *Künstler in Moskau: die neue Avantgarde*, Schaffhausen, 1988

Sovetski Khudozhnik (pubs.), *Molodye Zhivopistsy 70-x godov*, Moscow, 1979

CATALOGUES

Galerie de France, *Art Contemporain Sovietique*, Paris, 1987

Sotheby's, *Russian Avant-Garde and Soviet Contemporary Art*, London, 1988

Studio Marconi, *Artisti Sovietici Contemporanei*, Milan, 1988

JOURNALS

A-Ya, nos. 1–7, Paris, 1979–86

Durch 2, Graz, 1987

Flash Art International, no. 137, Milan, 1987

JOURNALS IN RUSSIAN

Iskusstvo, monthly journal of the Ministry of Culture, Union of Artists, and Academy of Arts of the USSR, Moscow

Sovetskaya Zhivopis, annual (approximately) compilation of articles and reviews, Sovetski Khudozhnik, Moscow

Sovetskaya Skulptura, annual (approximately) compilation of articles and reviews, Sovetski Khudozhnik, Moscow

Tvorchestvo, monthly journal of the Union of Artists of the USSR, Moscow

INDEX

ACKNOWLEDGEMENTS
The publishers wish to thank all those who
have contributed towards the illustrations
in this book. In particular, we are grateful
to the many artists who facilitated the
photography of their paintings and to the
photographer Lev Melikhov. Further
acknowledgement is made to the
following: © ADAGP, Paris DACS,
London 1989: 10; Iskusstvo: 24, 25, 28,
32, 34, 54; Viktoria Ivleva: 107; Igor
Makarevich: 105; Andrei Monastyrski:
102; Sotheby's: 5 (© Sotheby's 1988), 98;
Tvorchestvo: 16, 26, 27, 56, 70;
VAAP/Sovetski Khudozhnik: 14, 15, 23,
29, 30.